VOICES FROM THE SHADOWS

VOICES FROM THE SHADOWS

Women with Disabilities Speak Out

Gwyneth Ferguson Matthews

The
Women's
·Press·

Canadian Cataloguing in Publication Data

Matthews, Gwyneth.
Voices from the shadows: women with disabilities speak out.

ISBN 0-88961-080-0

1. Paraplegics - Canada - Biography. 2. Quadriplegics -
Canada - Biography. 3. Physically handicapped women -
Canada - Biography. I. Title.

RC406.P3M37 1983 362.4′092′2 C83-098969-2

Edited by Margaret MacDonald
Cover and book design by Liz Martin
Assembly by Sharon Nelson
Typeset by Gould Graphic Services Ltd.
Lithographed at Alger Press,
Oshawa, Ontario
Printed and bound in Canada

Published by the Women's Educational Press
16 Baldwin Street
Toronto, Ontario, Canada

To Bill —
of course

Foreword

In July, 1981, the International Year of Disabled Persons, I was approached by a representative of the Nova Scotia government who asked if I would be interested in researching and writing a paper and brochure on the special problems faced by disabled women. She felt that I, a paraplegic for seventeen years, would be able to identify more closely with potential respondents than would an able-bodied woman.

I accepted the assignment, and the representative's logic proved impeccable. I found the forty-five women I interviewed very willing to discuss their difficulties, but one admitted, "I wouldn't have opened up if you'd come in tottering on spike heels." Another added, "You can really understand what I'm saying. You've been there."

For five months I talked to women from all social, economic, and educational backgrounds; women with eighteen different disabilities. The sessions were long, sometimes two or three hours, and as they discussed their fears, worries, and opinions, they filled tape after tape. Feeling I was on my way to producing a study with a truly representative cross-section of concern, I was pleased, looking forward to beginning to write the paper.

That seventy-four page effort was completed in December, 1981. I passed it on to the government and awaited publication.

In March, 1982, I learned that the government was unwilling to publish. "Too depressing," I was told. Also, "Too much sex." Since I'd been hired to explore problems, I wasn't

surprised by the first comment; what did they expect? However, the chapter on sexuality was only seven pages and dealt with relationships and fears; it contained nothing explicit. I sensed I was hearing excuses.

During the interviews, I had been shocked and dismayed by many of the answers to my questions. I believed the public should read some of those replies, and I wasn't content when the government finally published a brochure which included some rather mild quotations from a few of the transcripts. I couldn't see how public awareness re disability might be increased by such a brief, sketchy effort.

Unwilling to give up the battle for the publication of the full paper, I finally called the press. And a small storm of publicity commenced.

One of the best articles appeared in the Toronto *Globe and Mail*, and it was seen by the women at Women's Press. Shortly afterward, I received a letter from them; would I be willing to tackle a *book* on the subject? Since it was becoming obvious the government position would never change, I said yes immediately.

This volume, a somewhat informal mixture of interview and autobiography, is the result. My respondents and I discussed many subjects, and the only one on which I received no comment was that of lesbianism and the disabled woman. I realize I did talk to gay women, but I'm afraid they were not willing to admit their preferences. Unfortunately. They would have added yet another perspective to the chapter on sexuality.

On a personal note, a number of people were of invaluable assistance to me; I'd like to take a moment to thank them.

First of all, the splendid women who permitted themselves to be interviewed. I appreciate every one, but especially four close personal friends: Marilyn, Joyce, Jennifer, and Debbie. Whenever I needed an emotion defined or an opinion underlined, they were ready and eager to help.

As were my friends Mary-Jean Stuart and Paul Jamieson, who assisted with proof-reading, suggestions, and substitutions that helped keep the book on the right track.

Also, I must say a special thank you to my husband's parents, Betty and Allan Matthews. Half-way through the second draft, I began to feel I'd never make it all the way through. Their support and encouragement was extremely important to me, and I'm very grateful to them for their help.

My own father, Mark Ferguson, and my dear, dear Elizabeth were equally supportive. Whenever I became dejected or frustrated, I went to them to talk out my grumbles. They always listened.

I mustn't forget to include the terrific women at Women's Press, particularly Judy McClard, and my editor, Maggie MacDonald. Working with them has been a real joy.

Last but definitely not least, I want to acknowledge the incredible contribution of my husband, Bill Matthews. Whether I needed lifts to interviews, chapters photocopied, advice on a million and one problems....I only had to ask. Thanks, hon.

GFM, September, 1983

Introduction

What makes this book important is its attempt to provide Canadian readers with a personal perspective on the lives of disabled women in Canada. Gwyneth Matthew's odyssey of learning to adapt to her disability is a familiar story to those of us with disabilities. There is nothing theoretical about her account. With emotion, tears, and humour, she relates her own story of a sudden illness at seventeen that left her paralyzed from the waist down, and her subsequent determination to live as full and interesting a life as possible. But this book also tells the stories of forty-five other women whom she interviewed. They talk about sexuality, accessibility, motherhood, housing, education, employment, and social assistance. Together they portray a group of fighters — women who in one way or another have all made a concerted effort to establish control over these essential aspects of their lives. In some cases they've succeeded; in others they haven't. However, it is their determination not to be dehumanized or made passive by their struggle that counts. It is their refusal to be a "patient", a "case", or a "victim" that we hear most clearly in their stories. As Gwyneth concludes in "Sticks and Stones", the chapter on labels, "My body may be disabled, but I am not! Whatever it is that makes me a human being, special to myself, there is nothing disabled or handicapped about it!" To this a second voice adds: "I'm a human being who just happens to be on wheels."

Many people, including the disabled, still believe the traditional myths about the disabled. Some of these negative attitudes have their origins in ancient religious beliefs that regarded the disabled as devil possessed, or as corporeal manifestations of family guilt. These prejudices have been buttressed by fear, particularly of the able-bodied, that their own good health might be a temporary state, that they too could be suddenly struck down by an accident, disease, or the effects of age, or, that through association with the disabled, a condition could be "catching".

The disabled also serve as a reminder that science and medicine are fallible — that some medical puzzles may never be solved. And in a society where everything is mechanized, computerized, and rationalized, it is truly terrifying to be faced with a condition that cannot be cured nor even be fully understood.

Dispensing charity in the form of alms and establishing houses of refuge for the poor and disabled have a long tradition in the Christian church. Charity helped insure one's place in heaven. This practice became entrenched in the church as an ethic of "good works" and gained momentum during the late nineteenth century when social reform movements were prevalent and modern medicine and special equipment made it possible for the disabled to live longer. Many important social services, policies, and even professions grew out of this period.

On the other hand, the negative effects of the charity ethic on our present-day attitudes and policies cannot be underestimated. For example, in Ontario it is not uncommon to see people sitting outside Dominion stores "begging" for receipt tapes to help buy a wheelchair. It is an unfortunate fact that the public accepts this situation and does not question the implication that the possession of wheelchairs and other prosthetic devices (braces, crutches, and so on) is not a right, but a luxury. Shamefully, the government reflects this same attitude.

It would be easy to blame the media for creating and maintaining many of the stereotypes with which the disabled still have to live. But the media only reflect attitudes that already exist in a body-beautiful society that tends to either

ignore or ostracize people who don't measure up to the norm. This state of "invisibilty" is particularly true for disabled women. In the past, if we were portrayed by the media at all, it was either as the sadistically insane, for example Bette Davis in *Whatever Happened to Baby Jane*, or as such pure vessels of light and goodness that we were unrecognizable as human beings.

Yet some positive images of disabled women are to be found in the media today. Movies made for TV like *Skyward* (in which a young paraplegic woman learns to fly); Lily Tomlin's brilliant comedy routine about a hang-gliding quadriplegic called Crystal Tumbleweed; the movie, *The Other Side of the Mountain* (a true story of a young women skier who is made quadriplegic by a skiing accident); and the appearance of the disabled on television series such as CBC's *For the Record*, *Sesame Street*, and *Facts of Life* (where a cerebral-palsied woman is a regular cast member), have gone a long way to help normalize the media image of disabled women.

Disabled women are susceptible to all the restrictions of being disabled in addition to society's expectation of them as women. This passive/attractive requirement that society imposes on women, reinforced by the media, makes every woman feel inadequate. It is not surprising, then, that women who are already disabled tend to have negative feelings about their body image. With amputated limbs, paralyses of the legs and arms, and other degrees of deformity, they know they will never look like a Playboy bunny, no matter how hard they try.

Articles, books, and films that treat the issue of the sexuality of the disabled usually deal with the male's needs and problems. Sometimes a small paragraph is included saying that women are usually passive partners in the sexual act anyway, so disabled women have nothing to worry about. Only recently have books and films come out advocating a more active sexual role for disabled women, including the possibility of lesbian relationships.

The paradox of disabled women and sexuality goes far beyond the sexual act itself. Reproductive rights is the big civil-rights battle being waged right now by disabled feminists,

both individually and collectively. Their demands include the right to have a baby, the right to adopt children, the right not to have children and to have access to abortion clinics, the right not to be sterilized without informed consent, the right to know about birth control and its side effects, and the right to access to the health-care system.

Because disabled women are not recognized as sexual beings, they often do not get the most rudimentary sex education. Information on birth-control methods and their consequences was, until recently, almost nonexistent and is still unavailable to many women in rural areas and in institutions. Disabled women do not have Pap smears as often as non-disabled women, largely because of the inaccessibility of doctor's offices. It is often thought that if disabled women are not sexually active, as is common in institutions, they don't need to have internal examinations. Breast self-examination is difficult for women who have disabilities that affect their flexibility or make their movements spastic or uncontrolled. The use of what many health experts consider dangerous birth-control drugs on mentally handicapped women is well documented. Until the early seventies, in some parts of Canada, it was legal to sterilize women with psychiatric problems. Sterilization of physically and mentally disabled women without their authorization is still a fact of life today.

The houses of refuge our well-meaning ancestors established to accommodate the disabled and the poor gradually grew into a system of institutions that served to keep the mentally retarded, the disabled, and other "unfortunates" out of the public eye, while at the same time salving a liberal conscience that wished to provide care and protection for the needy. Today, out of an estimated 2.5 million disabled people in Canada, approximately 275,000 are in institutions. Although strides have been made in the last fifteen years to educate the public on disability issues (inaccessible buildings, low disability pensions, neighbourhoods that reject group homes, and little or no financial commitment by various levels of government) independent living still remains out of the reach of many disabled people in Canada.

Institutions are daunting places. Gwyneth herself spent a year in rehabilitation at the age of seventeen. She relived the insitution experience with horrifying vividness when she interviewed women for this book. Institutions are places where, for the disabled, the struggle for the most basic human rights can become a comedy of the absurd. Intimacy between adults is always discouraged, and "entertaining" members of the opposite sex in one's room is frowned upon — indeed, many institutions stipulate that when disabled adults have opposite-sex visitors, the door to their room must be left open. Within the institution, living together as a couple is impossible, and marriage is almost unheard of.

Perhaps the most frightening aspect of institutions, however, is their tendency to encourage dependency. Because they feel safe and protected some disabled come to prefer living in institutions. People who become disabled in early adulthood, like Gwyneth, have an advantage because, unlike those who have been born with a disability, they *know* what it's like to live in the community and take part in its activities. They struggle fiercely against the concept of spending the rest of their lives in an institution.

In sharp contrast, those disabled from birth or at an early age are all too often segregated from the community through a succession of institutions. After spending their early years in the secure environment of a home or institution, they may or may not be deemed fit to go to school in a residential setting or a school program that is separate from regular classes. As Bonnie Armstrong, blind activist and board member of the Blind Organization of Ontario with Self-Help Tactics suggests, many people with a disability who attend public schools would never trade places with their more protected brothers and sisters in special schools for the disabled, despite the ridicule and isolation they must often endure.

"The only time we saw each other was in supervised class settings or in group program activities. In high school there were more opportunities to socialize but again they were always supervised.

"A lot of my friends felt disoriented when they got out of school. They sometimes experienced a bit of culture shock.

It was a very secure environment. You always knew where you needed to be and what was expected of you. It didn't have a lot of room for individuality or non-conformity."

Some provinces have made or are presently making arrangements to provide integration of physically disabled children into the public school system. However, at the moment, illiteracy in the deaf and blind in Canada points to less than equal access to quality education. It follows that, proportionately, fewer people who are disabled enter into post-secondary education.

In the area of education and employment possibilities, too often women with disabilities are guided into secretarial or menial work positions. Disabled men, on the other hand, are guided into more challenging careers. It is assumed that disabled women can stay at home and be homemakers, but American figures indicate that the unemployment rate of disabled women is higher than men because many women end up as homemakers by default, not through conscious choice.

Sheltered workshops are another kind of institution; they provide repetitive work for as little as ten cents an hour with few or no benefits. Although some workshops claim to provide training opportunities, working conditions and low expectations of productivity leave many disabled people with an unrealistic idea of what working at a job in the community is all about. It is possible to "train" in some of these establishments for as many as twenty-two years, learning to put nuts into bolts, paper into envelopes, and developing other such "marketable" skills.

As adults, people who are disabled can look forward to a life of menial labour and few employment opportunities. Employment studies on disabled people put their unemployment rate at close to 80 per cent or more. Disabled people are forced into workshop jobs because they can't get anything in the community. In the last few years, workshops have come under considerable criticism from the disabled consumer movement. Workshop managers have rationalized the ridiculously low wages by saying that higher wages would cause the workers to lose their disability pensions. They also argue

that workshops give the disabled something to do with their time.

One notorious light-bulb company in Canada uses and exploits disabled staff by hiring them at low wages to sell their product to consumers over the phone, implying to house-holders that the proceeds from the sales will be used to help disabled people. This company applied for an exemption under the Human Rights Code in Saskatchewan so that it could hire only disabled people when it moved its operation into that province. The combined efforts of COPOH (Coalition of Provincial Organizations of the Handicapped) and the Saskatchewan Human Rights Commission were able to prevent this goal from being realized.

Recently there have been attempts to humanize conditions in workshops by forcing them to comply with the rules and regulations in normal work establishments, through the actions of legal clinics such as ARCH (the Advocacy Resource Centre for the Handicapped), COPOH, and others involved with dis-ability rights. Some Canadian unions have publicly stated their abhorrence of working conditions in workshops, but none has done any widespread organizing in this area.

Issues like these, in addition to growing resentment to-ward the patronizing attitudes of service agencies, were responsible for helping to spark the disabled-rights movement in Canada. Organizing began in the early seventies, when bolstered by government recognition and funding through church grants and Canada Manpower work projects, many of these volunteer, consumer-controlled groups were able to put their plans into action. In 1973 the existing organizations voted to represent themselves on a national basis rather than allow the service agency, Canadian Rehabilitation Council for the Disabled, speak for them. A new cross-disability organi-zation was founded called COPOH, which now represents all ten provinces with links and liaisons in the territories. COPOH's provincial affiliates make up over eighty-four local groups and are ultimately accountable to an active membership of more than 25,000 disabled individuals.

The disabled-rights movement has had a ripple effect in Canada that is still being felt by social services, government

departments, and the general public. Simple changes such as ramps on concrete sidewalks, accessible apartments and government buildings are some of the changes we have seen with the appearance of disabled consumers on the boards of many service agencies, which were once dominated by well-meaning, nondisabled people. Legal clinics that cater specifically to the needs of the disabled have been established as a stepping stone to encouraging regular clinics to defend disabled clients. The movement has also been responsible for motivating our lawmakers to remove from the statutes many of the terms insulting to the disabled such as "imbecile" and "cripple".

Disabled feminists have long felt uneasy members of both disabled-rights groups and feminist organizations. They feel uncomfortable in the disability movement because it is often male dominated and at times blatantly sexist. Conversely, disabled women have had difficulty joining the women's movement because many of the services and meetings are held in inaccessible houses or offices. Women's conferences often take place in hotels or university residences that are not wheelchair accessible. Materials are usually available in print only, not in Braille or tape, and sign language is rarely used. Without accessible facilities, materials, and communication, women in wheelchairs and blind and deaf women are effectively barred from participating in women's movement activities.

A case in point was a national women's conference recently held in Ottawa. Two disabled women who attended phoned a month ahead to make sure the facilities and hotel were wheelchair accessible and that conference material and the agenda would be available in Braille. No one got back to the blind woman, and upon arrival at the conference she was told there was nothing available in Braille. After a five-hour bus ride, the woman in a wheelchair checked into the hotel only to discover the elevators were situated at the top of six steps. She was forced to use the freight elevators in the kitchen.

A new development has been the emergence of separate activist groups of disabled feminists. They are now speaking up, saying there are specific issues important to women with disabilities that must be recognized both by the disabled-rights

movement and the women's movement. The women's caucus of Voice of the Handicapped in Saskatchewan, the disabled-rights group for that province, is a good example of this new awareness.

In the feminist movement, it has been the lesbian disabled activists who have become the strongest voice, in both Canada and the United States. Nondisabled lesbian feminists have been more sensitive than heterosexual feminists in both countries in responding to the needs of disabled women at their conferences and events. Organizers of the B.C. Regional Lesbian Conference in Vancouver made an outstanding effort to make disabled women feel welcome by holding the conferences in the only wheelchair-accessible school in the city. They provided transportation, sign language, and a Braille program for disabled participants. Womynly Way in Toronto, a feminist concert production company, has sign language interpretation at all its concerts, and wheelchair accessibility is always a priority in planning.

Gwyneth's story and the stories of the women she interviewed teach us that people with disabilities have to get out into the world and advocate for change. Only by being very vocal, and a visible part of the community, can the disabled bring about a transformation in our society that will ultimately embrace and welcome those who, at first glance, don't seem to fit in.

Pat Israel and Cathy McPherson

Pat Israel and Cathy McPherson are feminists with disabilities who live in Toronto and are active in the self-help movement.

Within the shadows
A voice of who I was,
And who I am —
A stranger, even to myself.
My reflection frightens me.
Still, I exist;
You — with your strong, straight spine,
Your clear keen eyes —
You and I,
We share this place.
Come...
Draw closer...
Listen...
To the voices from the shadows.

JENNIFER SNAIR, 1983

The Awakening

December 18, 1963. The day my active, busy life exploded in my face. By the time I had picked up the shards and splinters, I was a different person.

I was sixteen, enrolled in the first year of junior college at a convent school in Nova Scotia, two hundred miles from my parents' home in Prince Edward Island. An only child, I missed Mom and Dad dreadfully, but my desire for a career in medicine overcame homesickness. I used what free time I had at the college to keep up on my dancing; I had nearly fourteen years of training behind me, and I didn't want my technique to deteriorate.

From the beginning of December, I hadn't been feeling very well. "Flu," diagnosed the doctor. Telling myself I'd be going home on the twentieth, I didn't let a persistent high temperature slow me down.

On December 16, we had started Christmas exams, and in the very first session, while I was struggling with French verbs, a brutal headache hit me between the eyes. In minutes, it had travelled up my forehead, across my skull, and down to the back of my neck — a narrow band of agony.

Apart from the inconvenience of developing a headache during exams, I wasn't overly concerned. Since puberty, I'd been prone to migraines; I shrugged off the vague concern that this pain was different. I already had too much on my mind and I didn't want to think about it.

For thirty-six hours, I managed to keep going, despite the ever-increasing severity of the pain, slightly blurred vision, and lack of sleep. My head hurt too much to give me any rest, and by the evening of December 17, I was exhausted.

That night, the pain slowly began to recede, and I dropped off into a confused nightmare. A few hours later, I awoke, reasonably bright, weary, but cheerful.

Muttering a fervent, "Thank God!" I jumped out of bed and headed down the hall to the washrooms.

I didn't make it. With a tremendous thump, I collapsed on the floor.

The other girls were at breakfast downstairs. When they heard the noise, they came running, and with their help, I was able to get to my feet and make my way back to bed.

Ten minutes later, I could feel nothing below my waist. To my frantically exploring hands, my body seemed swollen: bloated and lifeless.

I screamed for the dormitory sister, blurting, "I can't *move*! I can't feel my legs. Get a doctor!"

The nun made the call, but the doctor I'd specified was busy. He would come when he could, she reported. She looked at me sceptically; was I sure I was sick, or was I trying to escape my biology exam?

Experts tell us that there are four distinct stages that anyone attempting to adjust to a disability must pass through: shock, denial, depression, and adjustment. Shock is the briefest, but it's also the most frightening. All that terrible day, I felt a suffocating panic.

My friends poked their heads in occasionally, asking if there was anything they could do. Once I said that they could help me get out of that bed.

They put slippers on my unresponsive feet, slid them out of the blankets, and placed them on the floor. I grabbed the girls' arms, using the strength of desperation to try to stand. Useless.

I fell back, laughing hysterically, convinced that an outsider would find the scene hilarious. I told my fogged brain

that I was day-dreaming. Or perhaps I was insane. This couldn't be happening!

Already, I had slipped from shock into denial. I would not — *could* not — admit I was paralyzed.

Late in the afternoon, the doctor arrived. By then, the paralysis was spreading. My arms were weak and wobbly, feeling like overcooked spaghetti, my skin sensation fuzzy, and I was beginning to have difficulty breathing.

After a brief examination, the doctor, an old family friend, ordered the nuns to call an ambulance; he would contact my parents. That was a relief; I'd been worried about Mom and Dad all day. I knew they'd be upset, and since I was *convinced* I'd soon be fine, I didn't want them driving to Halifax for nothing.

I don't remember the ambulance, except for a fleeting moment when I indignantly informed the attendant I was nearly seventeen and was not going to the Children's Hospital.

Then I was at the Victoria General Emergency Department, and a neurologist was sticking pins in me, testing for feeling. Below my breasts, my body was numb, but my shoulders were so hypersensitive, the slightest touch started me screaming. Between howls, I waged a battle for air.

When I was turned on my side for a spinal tap, my neck went rigid. A moment later, my right arm stiffened, flying into an uncontrollable spasm. My hand nearly smacked the neurologist in the mouth. Only my left arm remained relaxed, and I could still move three fingers slightly.

Since morning, I had known something was wrong with me — denial didn't run that deep — but until I saw my spinal fluid, I had no idea how serious the situation was. Normal fluid should resemble tap water; I'd learned that from poring over medical books. The substance I glimpsed as the doctor gave the vial to the nurse was yellow and cloudy.

I had no time to assimilate the shock of that realization. I couldn't breathe, and a resident was telling me, "We're going to have to cut a little hole in your throat to help you breathe." Stunned, I whispered, "You'll put me to sleep, won't you?"

I'm told I kept asking for my parents, demanding to know when they'd be there. According to my father, I was more afraid for them than I was for myself.

An hour after my parents learned I was in hospital, and that the tentative diagnosis was encephalitis (sleeping sickness), they were on the ferry to Nova Scotia. Racing the worst storm of the year, they were in Halifax in what had to be illegal time. Naturally, they were terrified, but while they were deeply concerned about the paralysis, the thought of encephalitis had my mother worrying whether as to they would find me rational.

I can still feel the relief of seeing them come in the door. I was in an isolation room, where a hardbitten nurse was trying to force applesauce down my throat. I didn't have the strength to protest that I was too weak to eat, but I brightened immeasurably when I recognized my folks.

An open tracheostomy made speech impossible, but the nurse put a finger over the opening in the tube, and I was able to croak, "I love you. I'm sick!"

Then it went blank. With the reassurance of my parents' presence, of knowing my father, an Anglican clergyman, was there should I need a chaplain, and that my mother, my best friend, was beside me, I could let go and sink into the sleep I'd been fighting. I felt safe once more.

The doctors told my parents I was unlikely to survive. I appeared to have spinal meningitis (an inflammation of the membranes covering the brain and spinal cord); I'd had all the symptoms. The headache I'd described to the neurologist was typical, as was the neck rigidity. The 'flu' of the previous three weeks was probably the disease's incubation period.

But the extent of my paralysis wasn't typical. "There's something else there," claimed a pathologist. Turning to my mother, he added, "She's a very, very sick girl."

*

I don't know if I was asleep or unconscious for the next two months. Probably a combination of both. All my memories

are muddled, brief flashes and fragments, scenes from an incomprehensible experimental movie.

But I do recall the sighing sounds of the respirator, breathing for me, and the fear of suffocation every time the nurses suctioned the mucous from my bronchi. And I remember — too clearly — the stabbing torture of being turned down one side to the other, my rigid neck and arm resisting all the way. And the day the I.V. came out of my vein, and the nurse didn't spot it, so that my tissues were bloated as if I had elephantiasis.

I only wish I could forget.

One of my parents was always with me. They even took turns at night, trying to get a few hours' sleep on a rickety old lounge chair. I couldn't have made it without them. Alone, I could never have resisted the creeping languor, the urge to sink into oblivion. They pulled me through.

Gradually, I became more aware of my surroundings; I could tolerate short periods with the trach opening covered. This enabled me to talk to the staff and my parents. I particularly enjoyed the student nurses, who were only two or three years my senior, but my, "When I get out of here..." chatter provoked some facial expressions that made me very uncomfortable; I could sense those young women withdrawing from me.

I would probably have begun to worry, what if I don't walk again?, but one Sunday morning my neck suddenly started to vibrate. The pain was agonizing, but when the tremors ceased, I was able to turn my neck. The rigidity was gone, the muscles functioning normally.

A few days later, my left arm and both hands recovered. The right arm took longer, but then it had been pumped full of the I.V. drip and we had to wait for the swelling to subside.

Still, every day when the doctors stuck pins in my legs, always searching for sensation, I insisted I could feel the pricks! Eyes closed, as per instructions, I confidently asserted, "Left foot!" — only to open my eyes to see the pin sticking in the big toe of my *right* foot.

I was always able to make excuses to myself. That's because I was firmly, immovably, in the second phase of the adjustment cycle: denial. The mind cannot quickly accept the suggestion of a lifelong disability. Depending on the individual, rationalization can continue for weeks, months, sometimes even years.

Also, most doctors are usually reluctant to offer a definite prognosis so soon after the onset of disability — at least, to the patient; my parents were warned constantly. But unless the spinal cord is severed, there is always the chance that function will return, as it had in my arms and neck. Therefore, many doctors prefer to wait until the physical shock to the cord has abated before venturing a solid opinion.

In 1981, Alison, a woman who broke her neck in an accident two years before, told me about her encounter with doctors who did not wait: "The day after my accident, three or four doctors came in, looked down at me, and told me I was paralyzed from my neck down for the rest of my life."

Alison was then twenty-four. She'd gone through the window of a truck, and when her neck snapped, she became an instant quadriplegic, all four limbs paralyzed. As she talked to me, her eyes flashed with remembered fury. "I told them to go to hell," she snorted.

Those doctors should have reserved their dire opinions. Alison recovered function in her neck, shoulders, and partial use of her arms.

I've always been grateful to my doctors for their thoughtfulness. And yet...when the three months it takes the cord to recover from shock were up, and my lower body was not responding to therapy, I wish they had begun to caution me that I *probably* would not walk again. I was starting to feel the whispers of private doubt, but in the depths of denial, I couldn't voice those fears. I would have fought any suggestion that I might not regain the use of my legs, but I would have been forced to begin dealing with the possibility.

And a sweet, elderly nurse inadvertently caused me more difficulties by being too reassuring. "You'll be going to the

rehab centre soon," she enthused. "They're miracle workers there. They'll have you up and dancing again in three or four weeks."

Goodbye doubts! She'd been a nurse for forty years; she *had* to know what she was talking about.

It's never easy to face the truth, to realize you are going to be in a wheelchair for the rest of your life. But it's so much harder when professionals are either thoughtlessly cruel, as Alison's doctors were, or overly kind, telling a patient precisely what she wants to hear.

When I began to experience burning, grinding pain in my legs and abdomen, I interpreted it as another favourable sign. If my legs weren't working at all, would I be able to feel this? I asked myself. I also questioned the staff, but no one informed me that the majority of paraplegics and quadriplegics usually feel some discomfort, and that a small percentage live in constant agony. The pain is set off not by the normal function of the nerves, but by their dysfunction, by impulses incorrectly interpreted in the brain.

Then my legs started moving, as if they had minds of their own. I yelled, "Hey!" I can move them!", and the nurses just smiled. Bladder spasm was solely responsible for the movement, and yet my hopes were permitted to soar. Couldn't *someone* have gently told me the truth?

For two months, my parents had been staying with our bishop, but by February my father was commuting between Halifax and his P.E.I. parish, leaving on Friday, and returning on Tuesday. Mom remained with me, but she no longer slept next to my bed. I knew it wasn't easy for her to say goodnight after visiting hours, but I realized she wanted me to become less dependent on her. She'd always been the sensible one of the family.

Once I was allowed to have visitors, my friends came regularly, organizing themselves in shifts, so I usually had someone to talk to. When the doctors decided I had recovered

sufficiently for them to take the trach tube out, talking suddenly became far easier. I'd forgotten the pleasures of verbal communication.

I gained tremendous strength from the support of those closest to me. Many of the women I interviewed weren't so fortunate.

At twenty-eight, Marsha was divorced with a young child. Her rare spinal disease carries a 50 per cent mortality rate, and her family couldn't deal with the frightening prognosis: "My father had Gehrig's Disease, which was terminal. He went into the wheelchair the same time I did. My mother was struck very hard by everything; my family cared, but they couldn't handle it. Coping with anything that might be public or stressful was — is — very hard for them."

I always knew that my family would love me, no matter what. In the days that followed, I needed their support, as I never had before. Without it, I doubt I could ever have pulled myself together. Certainly, I would never have survived the nightmare of rehab.

*

On March 1, 1964, two weeks before my seventeenth birthday, I was transferred to the rehabilitation centre by ambulance. I was dizzily excited about the move, trustfully believing I was being sent to learn to walk again. In reality, I was going to learn how *not* to walk; how to live as best I could, without the use of my legs.

My first glimpse of the building was disappointing; I'd seldom seen such an ugly, forbidding pile of bricks. The rehab itself was one floor of an ancient convalescent home, and the view inside was no more reassuring; the corridor I was wheeled down was dark and dirty, the dingy, yellow paint peeling, and the old grey-and-green linoleum cracked.

In the small residential wing, which housed some two dozen patients, we turned into the ward that would be my home for the next six months.

I wrinkled my nose in distaste: four metal beds, painted dark brown, were topped with bars that looked as if they belonged on fancy sports cars. The plaid spreads and matching drapes were a bilious green and yellow, the cracked walls a revolting mustard. "How depressing," observed my mother.

The nurses put me to bed, and I said goodbye to Mom. Alone, in that horrible place, I battled to control tears of disillusionment. My surroundings did not seem conducive to miracle working.

A moment later there was an ear-splitting crash outside. The door opened, and in charged two young girls in wheelchairs. They rolled over to my bed, and I was astonished by the ease with which they manipulated those contraptions. *And* by the way they looked sitting in them — like two perfectly normal teenagers.

My new room-mates introduced themselves, all the while sizing me up. Janice, a pug-nosed redhead was a year older than I; Ann, a pretty, but hard-looking brunette, nine months younger. I wasn't sure they liked me, but it was nice to have young people for company, especially after weeks in isolation.

Plucking up courage, I timidly asked what had happened to them. "Accident," snapped Ann, her voice bitter.

"I was sick, transverse myelitis," added Janice wistfully.

"You'll walk again soon," I offered.

"No way. Neither of us," said Ann.

Alarmed, I stammered condolences, but I didn't miss the glance that passed between them. I knew they thought I shared their fate. "I was paralyzed from my jaw," I protested. "I'm getting better every day. My legs'll come soon; I know it."

Ann was silent, but her arched eyebrow said, "Sure, kid. If that's what you want to believe."

At that point, I *had* to believe it. Recovering my legs was the only goal in my life. I was a frightened ostrich chick, sticking her head in the sand.

Even years later, Alison remembered how it had felt: "For the first few months I thought I'd walk again. You know, having nothing but your head; then you get a shoulder

movement, and then an arm. You think it's going to keep spreading down."

Ann and Janice departed for physiotherapy, and I forced their words out of my head. When a nurse came to get me up for dinner, my excited optimism had returned. I hadn't eaten at a table for almost three months; a person can grow mighty tired of eating alone.

The nurse left me at the dining-room door. Even though my right arm was still sluggish and the imbalance caused the chair to go in circles, I inched my way in. Controlling the ancient, hospital-issue chair required steady concentration, so it wasn't till I heard Janice's voice calling to me that I looked up and took notice of my surroundings.

I immediately recoiled in horror, a wave of violent nausea washing over me. The room was filled with young people not much older than myself, and one or two elderly men, all sitting in wheelchairs. The majority were quadriplegics with purple accident scars on their necks and throats. Frightened but fascinated, I watched one fellow trying to pick up a paper cup, using his wrists pincer fashion. Another, who appeared unable to move at all, was being fed by a nurse. A third was using his teeth to strap a splint with a fork mounted on it under his lifeless hand. The thought flashed into my mind: this is where you've been. This is what you've escaped.

Averting my eyes, I joined Janice and Ann. The food was atrocious, but I would have choked on filet mignon. And my conversation was as bland as the stew; I wanted only to finish eating and get out of there.

In the evening, my parents tried to jolly me out of my mood. That morning, the doctor had ordered my catheter clamped off for three hours at a time; my room-mates were on "open drainage", with rubber bags to collect their urine strapped onto their legs. The nurse who provided the clamp had smiled, "Got to keep that bladder stretched."

My father argued, "If it isn't going to work again, why bother?" When the nurse explained that stretching the bladder

would mean they could attempt to retrain it later, I cheered up considerably.

Seventeen years later, in the same rehab centre, despite a beautiful new building, Alison's experience was very similar: "My family and friends were always saying, 'You've got this much back, just keep working at it.' They come in, morning, noon, and night, doing my leg stretching for me. 'You've got to keep in shape. You've got to keep your muscles strong."

Also, many of the women told me how, at this point in their rehabilitation, they were constantly exhorted to 'have faith'. Now, faith *can* be of tremendous benefit; in fact, few of us could have got through rehab without it. However, faith must be applied in the right way. What a person in that situation needs is the faith to *carry on* — to resist the urge to give up. Sitting around waiting for miracles can be disastrous. The variety of faith advocated for most of us can give rise to crushing guilt. It can make a person think, I'm not getting better because I don't have enough faith. Maybe I'm really a terrible person. Children are particularly susceptible to this danger.

Dr. Brandt is a retired psychotherapist who specialized in rehabilitation for many years. She's also a quadriplegic as a result of having polio when she was six. "One of the worst things you can do to handicapped kids is to say, 'Now you just try hard enough, and you'll be able to walk," she commented. "That makes the poor little souls responsible; makes them feel guilty."

Alison and I both heard a great deal of, "Determination. That's all it takes!"

Within a week of my arrival at rehab, I had no time to listen to philosophical injunctions. I was far too busy running off to therapy. The pace set by those young physios and occupational therapists was exhausting. From dawn to dusk, when they said hop, we turned into Mexican jumping beans!

A nurse woke us at 6:30, although in those early weeks, when I was learning to dress myself, I had to start moving a half-hour before Janice and Ann. They could pull their things

on in five minutes, while I struggled for an hour with slacks and socks. I didn't even know how to sit up unaided, and the nurse often returned to find me lying on my back, the foot I was dressing held over my head, as I thanked my genes and dance training for my superflexibility.

Chair class (exercises in the wheelchair) commenced the moment breakfast was finished; then back to our beds for stretching exercises where our legs were pushed and pulled into crazy angles to prevent the muscles from contracting and locking in one position. At mid-morning we were whisked off to the gym for exercises on the mats, and pulling weights. In the afternoon, it was occupational therapy, where I painted nightmare abstracts; then more weights and lessons in transferring from chair to bed, toilet, bath, and car. By dinner time, we were a dreary-looking lot.

Working at that pace, the body adapted quickly. But while our bodies were retrained, our mental and emotional problems went virtually ignored. I asked Marsha what she thought of her rehabilitation program: "I didn't like it. Oh, the physical aspect can't be beaten. But there was absolutely no support for my family, who didn't understand what was taking place, or for myself."

In 1981, seventeen years after my sojourn there, Alison had identical complaints: "I couldn't name one person that you could go to; they don't have one. They tell you to talk to anyone; that the nurses will sit down with you. I found that if you talked to nurses, it just got spread around the hospital. Or they told their families; or *your* family. I would have liked to have a professional to talk to; even somebody in the same boat, in a wheelchair. You could talk yourself blue in the face to some of those nurses and they wouldn't understand."

There has never been a psychiatrist on staff, which strikes me as decidedly peculiar, given the emotional traumas experienced by the patients over twenty-five years. There is a psychologist, but Alison explained, "He does testing for people

with strokes...that kind of thing. I wanted to talk about my future, and they said, 'That's not what he's here for.' "

An organization for the disabled now sends in counsellors, and I'm told that one or two of them are quite good. But there are too many patients for too few counsellors, and those counsellors have clients to see all over the province.

As we had no professionals to talk to, we turned to each other. Rehab romances were the norm, so common that the staff seldom reacted to couples kissing in corridors. In that unreal world, relationships flourish, and the rehab romance is the safest of all. The partners are both disabled, so embarrassing explanations are unnecessary. Each knows what the other is going through. Everyone lives from day to day so the future is never discussed. And the brutal physical regime is lighter when shared.

Above all, for any newly disabled person, there exists an overwhelming need to prove they are still attractive to *someone*. Wheelchairs or crutches can wreck havoc with a young woman's self-image. Hence, the rehab romance.

In 1964, thirteen of the patients who lived in were under thirty, and only three of us were female. Unbeatable odds... however the alliances we formed were rather unusual. Janice was enamoured of a suicidal quad, who would get drunk (strictly against the rules) and try to throw himself out of bed, hoping to break his neck ("For good!"). Ann was involved with an insufferably conceited hemiplegic (one leg and one arm paralyzed) who was always in some sort of trouble, and I spent 90 per cent of my free time with Bert, a Newfoundland fisherman, with whom I had absolutely nothing in common.

We all pretended we were in love, but in retrospect, I can see the reality. It was need not love. We were young and worried about ourselves as sexual beings. There was neither sexual nor emotional counselling, so we paired up to experiment.

Not that we could get too far. There was no privacy; we weren't even allowed to close our doors. Irina, a paraplegic in her mid-thirties, remembered those constant attempts to

duck the nurses: "We went down to the tunnel that led to the other hospitals; we hid in the elevators after hours; we stole the keys to the lab from the nurses' desk and snuck in there — all kinds of crazy things. It wasn't as if we were looking to jump into bed; we knew that was impossible. All we wanted was some place to neck, to find out just how much sensation we had left, to see if we *could* become properly aroused — anywhere a nurse or physio wouldn't barge in, unannounced. Those people *never* knocked."

And I was never so grateful for Bert as on the soul-wrenching day I realized, finally, that I would never walk again. For weeks, my hopes had been melting like sherbet on a hot summer day, but I had been clinging blindly to the reassurances of my father. Then, on Monday morning rounds — the doctors' traditional tour of the wards to discuss the patients and plan future therapies — Dr. Johnson was introducing us to new physios. Explaining Janice and Ann's disabilities quickly, he came over to me.

"Gwyn's a transverse myelitis, just like Janice," he said.

If there are words to describe the horror, the pain, the desolation of that moment, I haven't been able to find them. My heart seemed to stop, and violent nausea convulsed my stomach. I remembered the hospital pathologist saying I had something else, something other than the meningitis. Had they, after all, been able to diagnose the complication?

The medical people had gone. Tears welling, I glanced at Janice; had she heard? She was rolling toward me eyes moist, gentle compassion in her smile. Silently, she reached out to me. I could hold my head erect no longer. Resting it on her shoulder, I began to sob.

That evening, I went to see Bert, and for once, the nurses left us alone. Softly, he told me that transverse myelitis simply meant crosswise paralysis. "It's a fancy doctor's term; a way of pretending they know what happened to you and Janice." As a faint flicker of hope crept through me, he added, "But I'm afraid Johnson was telling them — and you — that whatever did it to you, they're pretty sure it's permanent."

Taking me in his arms, holding me, over the arms of our chairs, as tightly as he could, he ordered, "Cry."

I did.

I was out of the denial phase.

<p style="text-align:center">*</p>

There are as many reactions to the realization of permanent disability as there are people; each individual responds differently. Some become so angry they appear unbalanced: throwing things, cursing, screaming at staff and fellow patients. Others cry constantly, like bereft children. Still others vacillate between the extremes, raging one moment, sobbing the next.

These reactions are *perfectly normal*. In this stage of adjustment, if there are no signs of depression, doctors begin to worry. If we're ever to live normal lives, we have to let the grief out, deal with overwhelming initial reactions and work through and overcome them. We all need time to grieve for our lost abilities and life-styles no longer appropriate to us. And we need time to stop yearning for the past, to learn to remember able-bodied days with affection, rather than pain.

A few staunch souls appear to make the adjustment quickly. Others take much longer. Back in 1964, of the inhabitants in Room 11, Janice seemed the sanest, letting go of her emotions only when a bit tipsy. Since that was a rare occurrence, I seldom saw her cry. Ann never broke down, but her bitter face masked depths of seething anger. When she was in a bad mood, we all stayed clear.

As for me, I was in poor shape and I knew it. In the midst of that busy hospital, I felt totally miserable and alone. During visiting hours, I managed to smile, realizing that my father was in worse condition than I. He was *still* in denial. It was my mother who was the strength of the family; instead of moping over losses, she concentrated on possibilities. When I was with her, I could draw on *her* equilibrium. At those times I felt human.

Unfortunately, she was there only two hours each day, and once Bert went home, I began spending more and more hours on my own. I threw myself into therapy, resolving to strengthen every working bit of muscle to its fullest. After hours, I turned to my writing and churned out reams of stream-of-consciousness poetry.

Writing was my safety valve. (It still is.) It helped me express my turbulent feelings, to get them out of my head in one piece before my father interrupted saying, "You mustn't think you're not going to walk! I don't believe that. You wait and see; God will work a miracle."

Poor Dad, he *had* to cling to the only type of faith he knew. But even then, at the worst stage of my life, an inner voice was telling me, "You've had your miracle, kid; your arms!" Whenever my thoughts strayed to suicide, I brought them back by remembering the months when I had only the weak waggle of three fingers.

That was the one memory I could safely refer to. The others — of the rehearsal hall, of galloping horseback down country roads, or high-school sock hops, of riding a bicycle — were sheer torture. And whenever dance of any sort came on the rec room T.V., the images on the screen forced me to flee. I couldn't bear to watch, not for one moment.

And I had another monumental problem to deal with: the abdication of my friends. When I realized my disability was permanent, *they* too soon caught on. Their visits, formerly so regular, dwindled; by July, only one old faithful still came to see me. I felt deserted, and it was as if they had said, "You're not good enough for us any more."

Alison's able-bodied friends reacted similarly: "A lot of my old friends haven't been to see me. When I ask why so-and-so hasn't been, I hear, 'She doesn't want to see you in the wheelchair.' I sensed the ones that did come were uncomfortable. They always wanted to help, but they weren't sure what to do. It's like they've got their own lives and I'm not part of them anymore. It hurts."

When friends abscond, a newly disabled person is more likely to fear being seen by the general public. That worry can lead to what my mother used to call "that rehab mentality". In other words, a person may withdraw from the real world, turning to fellow patients for emotional sustenance.

I think I avoided that trap because I didn't get along with Janice and Ann very well. Having three teen-age girls in one room is never a wonderful idea (every little disagreement winds up two against one), but there was nowhere else to put us. Janice and I drew close in later years, but in 1964, my mother was my best friend. She worked diligently at making me look beyond the hospital walls.

Alison, however, became deeply embroiled in rehab society: "It was my own little world, perhaps because everyone else was in chairs and I didn't have to worry about going out where people would look at me. It's not meant to be a protective society, but sometimes it gets like that. It's supposed to help you overcome your handicap, but I felt safe there."

This kind of dependency happens easily, but it's awfully difficult to escape. I asked Alison how she felt when she finally did appear in public: "I hated being out. I couldn't stand it. My reaction was, 'Get me back to the rehab; I just want to hide in my room.' The stares from people were my biggest handicap."

Marsha understood why it was so hard to go out: "In rehab, you're very positively programmed about your ability to be independent. But while someone was programming you, no one was programming society to accept you."

As August slipped away, I realized I was going to have to take that big step very soon; I was going to attempt to integrate myself into able-bodied society by enrolling in university. Visions of crowds of students filled me with apprehension. I wasn't even close to adjusting to my disability, but I felt I could draw on my acting talent enough to make the other students *think* I had it all together. At least I hoped I could.

All through rehab, I had been longing for an older, more experienced female paraplegic to talk to, but there was no

one around, and the doctors did not think it important to have someone come in and see me. I think that was a terrible mistake and I believe that the kindest thing any doctor can do for a newly disabled patient is to put her or him in touch with someone who knows the ropes; someone who has encountered the pitfalls, and has learned where to find the pleasures.

As more disabled young people go into counselling, they will probably have kindred spirits to question and confide in, but Janice, Ann, and I had no one. Nor was there anyone with whom we could discuss our sexual selves. There were books and films for the males, but nothing at all for females!

It took me weeks to summon the courage, but just before discharge I approached Dr. Johnson. "What...what about sex?" I stammered.

Uncomfortably, he replied, "Well...it can still be rewarding." Brightening, he added, "You can still have children, you know."

I did know, and I had no idea what "rewarding" might mean. However, the grim expression on his face forbade further probing. I had to be content with those few words.

Ten days before college registration, the same doctor smilingly wished me luck and signed my discharge papers.

*

While I was in rehab, my parents had moved from Prince Edward Island to Halifax. Dad had been appointed Anglican Hospital Chaplain, and the Diocese had allocated us a modern, two-storey house. Inside, there was a downstairs bedroom, a comfortable den, and a small washroom, ideal for someone in a wheelchair. By the time I was ready to move in, a ramp had been added.

That first morning, I rolled into my new room and was confronted with a full-length mirror. Afraid, I turned away. For months, I'd avoided the long mirrors in the gym. I could bear to look at myself from the shoulders up, but I hadn't wanted to see myself in the chair. Taking a deep breath, I faced my reflection.

What a surprise! Apart from the despised chair, I could see that I was as tall and slim as ever, my figure wasn't too bad, and the extra growth on my platinum hair was a decided improvement. I was also amazed at the appearance of my legs. Thanks to the painful bladder spasms (which I'd cursed), the muscles hadn't atrophied as much as I'd feared. My calves were more slender, but still shapely. Briefly, my self-image soared. I promised myself that I'd make the best of what was left. I'd search for ways to improve my appearance through wearing clothes that would emphasize my good points and distract from the weak.

Due to problems with accessibility at the convent and other schools, I had applied to St. Mary's University, where all classes were in one elevator-equipped building. I'd been accepted, even though SMU was then an all-male institution. Suddenly the wheelchair became an asset. If the co-ed schools had been accessible, St. Mary's would never have taken me. The idea of invading a men's university was terrifying, but sitting there, staring into the mirror, I decided there was no way I was going to be the little disabled girl, hiding herself in a corner. The very idea was repulsive. Somehow, I had to rescue my damaged ego; I had to go into SMU behaving like the young woman I was.

From the first morning, I worked very hard at making myself one of the gang, and if I didn't succeed, the students certainly treated me as if I belonged. I'd been a child actress, and those abilities came in handy, especially when it came to keeping a cheerful expression on my face. Aside from my studies, I spent that fall and winter finding substitutes for the things I could no longer do. Teaching myself to play guitar and cultivating my singing voice helped take my mind off horses and ballet shoes. New friends relieved some of the bitterness over the behaviour of those who'd deserted me. I took part in college activities, daring myself to enter talent competitions. And whenever I felt seriously depressed, I wrote poetry. I even learned to like university football.

By spring, I was engaged.

Still, I had some dreadful problems. At Christmas I had been forced to concede that I couldn't cope with the long hours in the chemistry lab. When I dropped that course, I also relinquished my last hope of being able to continue in pre-med.

And I hadn't succeeded in my attempts to appreciate dance from a visual point of view. At the Saturday night dances, I was able to watch the gyrations of the time. But whenever I tried to look at something serious, like ballet or ballroom dancing, I became miserably depressed. I felt as if I were starving, the craving for the love of beauty-in-movement was so strong. I began to realize that I'd never fully adjust to disability until that yearning was satisfied.

One snowy weekend in 1965, I finally hit upon the answer. While aimlessly switching T.V. channels, I stumbled across coverage of the World Figure Skating Championships. Thinking it too much like dance I almost turned the set off.

However, something prompted me to watch it for a while …and when the hour was over, a huge, vital piece of myself had been restored. Silly as it may sound, the skating provided everything I needed, without setting off painful memories.

That afternoon, I caught hold of the beginning of adjustment: of the ability to accept myself and my life. There had been a gaping, drafty hole inside me, and the discovery of skating had started the healing process. For the first time, I felt almost complete. At peace.

I'm not saying it was all smooth sailing after that. I've had so many setbacks I don't even remember some of them. First, my mother died, which threw me right into a second adjustment cycle. Once again, I faced shock, denial, depression, and adjustment. Then, every few months, the level of physical pain in the paralyzed areas of my body increased. Anger helped me to deal with the pain; I refused to allow it to drive me to suicide.

Later, after I was married, there were three miscarriages. Each time, the old cycle repeated itself. I was getting dreadfully tired of it.

In 1979, I faced the worst test. I had surgery for the pain, and the neurosurgeon assured me the operation would not harm what sensation I had. But something went wrong. The next morning, I developed pneumonia and one of my lungs collapsed. In intensive care, the scene was practically a play-by-play repeat of my 1963 illness, complete to tracheostomy. In the fight for air, I didn't notice I was missing feeling.

When I came home two months later, I blamed my depression on the accidental damage to my vocal cords; my soprano tones were gone. I could speak, but my voice was weak and scratchy, as if I had a permanent cold. And the reduction in pain didn't help as much as I'd hoped.

I was in the bathtub when the full realization hit me; almost all of my sensation was "off". In some areas, such as my hands, it was only slightly below normal; in others, particularly in my back, I'd lost more than half of the feeling that I had before the operation.

Hysterical, I began calling doctors. One decided I had a syrinx, a ballooning of the spinal cord. A progressive condition. That prognosis gave me an understanding of the fear people with degenerative diseases endure. As Monica, who has multiple sclerosis, said, "You never find a safe place because you never know when it's going to strike again, or how much damage it's going to do. I've pretty well adjusted to paraplegia, but I don't know what may happen tomorrow. For all I know, I might become a quad, overnight."

I only had to cope with that panic for six weeks; tests proved I did not have a syrinx, nor any other condition that might explain the loss of feeling. Once again, I was a medical mystery.

After eighteen years, I was well acquainted with the adjustment cycle, and I knew the depression would eventually lift. One by one, I would get through the stages, then something would come along and return me to myself. I just had to stick it out. Then the pain recurred. It came back twice as severe, involving my entire body, from my neck to my toes.

I didn't get out of that predicament by myself. The honours go to a brilliant young neurologist, who gave me a drug I'd never tried. It wasn't even a pain killer, but an antispasmodic for multiple sclerosis. In one hour, sixteen years of constant agony were over. For the first time since junior college, I was in *no* discomfort.

That wild feeling of freedom made pulling out of depression child's play. I started writing again, and a friend introduced me to tutoring illiterate adults. That kept me so busy I forgot about missing my singing voice, and before I knew it, I'd become used to having less feeling.

I had an entire year with virtually no pain, but finally I had to stop taking the antispasmodic; it was interfering with my normal muscles. The substitute I'm using now isn't as effective. I have my bad days, but I also have the good. The year's rest gave me time to think things through, to realize, I've come this far; I can make it — no matter what.

I don't know if I'm going to have to face the adjustment cycle again, but I acknowledge the possibility. If it happens, I can get through it. I suppose the only advice I might have for anyone newly disabled is to take it day by day, to realize that shock, denial, grief, and anger are *normal* and that they will pass. Eventually, that sense of peace, of becoming a whole person again, does arrive.

Adjustment takes time.

Reading, 'Riting, and 'Rithmetic

"We can't do manual labour, so we have to cultivate our minds," said Sarah, passing me a cup of tea. "The more disabled you are, the more you need a good education. I only wish it wasn't so hard to get."

A lovely young woman, with an intelligent Modigliani face and startling sapphire eyes, Sarah was only sixteen when I first talked to her, but her precocious maturity made her a contemporary. In the months of interviewing that followed, I found this little-old-woman quality common in those disabled from birth or early childhood. Too many have been forced to grow up too soon.

Sarah became disabled in a car-truck collison that killed her father, and seriously injured her mother and brother. The severe damage to her spinal cord left her paraplegic, with no movement, and little sensation, from her ribcage down. Following months in hospital, Sarah, the last of the family to be discharged, returned home. She had learned to use a wheelchair, but her physical problems were far from over. Bladder infections, curvature of the spine, and pressure sores (the result of sitting or lying in one position too long) kept her in and out of hospital, away from school and her studies.

"She was spending three-quarters of her life in there," said Jane, her mother. "I would say I was worried about her education, and they'd ask, 'Why doesn't she go to school

here?' They had school three mornings a week, for just one hour each day, and the teacher had kindergarten to grade twelve, all in the one class. And two of those mornings, Sarah had to do a catheterization (to drain her bladder by inserting a tube through the urethra). If she didn't, and she let herself get wet, they yelled at her."

The hospital system of three hours tuition a week, with all grades in one class, seems woefully inadequate. Perhaps an organized group of tutors (possibly volunteers), working one-to-one with disabled children, might go a long way to alleviate the pressures on parents who are worried that their children are never going to learn the fundamentals. It would also ease the intolerable pressure to "keep up" for the children.

Sarah feels the lack of an in-hospital educational system has done her considerable, perhaps irreparable, harm. Meanwhile for years, despite the months of absence, her old school passed her. I asked if she thought that was wise, and she shook her head: "Because of it, I missed all the basics, and that's hurt me, particularly in math. I never got grades seven and eight, but I got nine! I tried to go for upgrading, and they passed me — again — even though I didn't do well at all. Then I went back into hospital for a check-up, and all hell broke loose: pressure sores, which required plastic surgery, infections. I never had any problem when I was home, but...."

Sarah shrugged expressively, and her mother took over: "She tried to study, but she couldn't. The little kids were in and out; she had to be in bed, with lights out, by 8:30; and she couldn't write because she was on her stomach so the scars could heal. The kids erased her tapes — everything she was trying to learn, and she wasn't allowed to study after it had quieted down. It was useless."

Such experiences are unbearably frustrating, especially for anyone as bright as Sarah, who knows she has the intellectual potential to do whatever she chooses. The best brain in the world needs guidance, in a setting conducive to learning; I doubt if anyone could be an A student in the noisy chaos of a children's ward. I agreed with Jane, when she added,

"I think they should have a separate spot for someone who's in for months at a time, and the other kids should be kept out of her room."

Able-bodied students know how hard it is to go back to school after the mumps or measles, after being at home for a week or two. The other children have been there all along, moving ahead with the teacher, tackling new material. Catching up is never easy.

It's much more difficult for those who, through no fault of their own, have been away for weeks, even months. Teachers are busy people; they don't have the time to sit down and coach one child in half a year's work. Therefore, the child who cannot absorb the missed material before exams is either given an automatic pass (as Sarah was), or is held back, watching her friends forge ahead, and dreading the next year with unfamiliar, *younger* classmates.

Sarah missed grades seven and eight because her family lived in the country, where one school refused to take a girl in a wheelchair. Although another school accepted her, her mother had no car and they couldn't afford a cab. How was she to get to classes? Obviously, she couldn't manage it, and while her mother worked, and her brother went to school, Sarah stayed at home, all alone.

Chris and Cindy, sisters with muscular dystrophy, lived in the city, but they recalled similiar difficulties: "Mom was told the bus would come to pick us up, but it turned out the only available transportation was one retired cab driver and a car. He had no idea how to handle handicapped kids. I think we could have coped with the work-load very simply, but it was the getting there and coming home, being dropped, and so on."

The sisters struggled on for a few months, but then they, too, moved to the country. According to Chris, things went from bad to worse: "They sent a tutor, who was supposed to be able to handle MD, but she was from England, where MD meant mentally deficient. She came in, expecting to teach

retarded kids to say 'Mom', and Mom assured her we had long since mastered that word."

While Sarah, Chris, and Cindy have had to cope with serious interruptions in their education, Susan, who also has muscular dystrophy, was never able to go to school at all; the only one in her area was inaccessible. "I taught myself to read and write," she said proudly. "I'm not very good at spelling, but I can use a dictionary, and I manage."

Steps, flights of stairs, narrow washroom doors, no elevators — sometimes it seems like an able-bodied conspiracy to shut disabled children out of the public school system. And most of those who've been disabled from birth or infancy pointed to yet another painful hurdle they've had to cross: the difficulty of relating to the other children, and of tolerating their cruelty.

Jean, who is hard of hearing, knows just how nasty kids can be: "Some of them would pretend another was lying, and of course, I couldn't hear properly, so I wouldn't know. They told me other kids said bad things about me, and it turned out they didn't. Or they'd get me into fights for no reason; they'd blame things on me; and they taught me bad words and bad habits."

Wendy, whose muscles are too short for her bones, and who has been quadriplegic since birth, complained, "They would grab the handles on my chair, and run with me, stopping just short of the top of a flight of stairs. It was scary. And whenever there was trouble, they'd lie, and the teacher would always take their word over mine. When the superintendent found out what was going on, he nearly had a fit."

But for all the taunts and the "practical jokes", these women would not have missed the vitality of a "normal" school situation for anything. Too many disabled students spent their early years in special classes, segregated from mainstream school. Others were completely separated from physically normal students, boarding in schools for the blind or deaf. Far too many of the women I interviewed know the

pain of being set apart. They've been "different" from birth, and segregated classes do much to reinforce that "difference". It's not fair to a child.

*

My paraplegic room-mates, Janice and Ann, both encountered enormous difficulties when they considered returning to high school after rehab.

Janice was eighteen by the time she was finally discharged, and she decided against continuing her education. Instead, she went to work on an assembly line, and without a grade-twelve diploma (grade twelve being senior matriculation in Nova Scotia), she had to be content to make 85¢ per hour.

Ann started in grade eleven, but the hassles of being carried on and off the country school bus and of feeling years older than her able-bodied class-mates (who had no inkling of the maturing experiences she'd been through) wore on her nerves. She, too, dropped out.

Dropping out is a common problem for disabled students. Chris and Cindy told me about the exhausting effort to keep up, which became particularly difficult in the higher grades: "We took correspondence courses, but by grade ten, the work-load was becoming so extreme, so heavy, that it meant we were writing all the time. We were finding it really painful, and back then, they wouldn't use tape-recorders. So we missed high school."

That took me back to my first weeks in rehab, when Ann was struggling with a correspondence course. She was a bright girl, who wanted to learn, but we had physiotherapy from breakfast till dinner. By the time she was through pulling weights, she had no energy or enthusiasm left. Eventually, the books were put aside.

Patty, a dark-eyed, fun-loving woman in her late twenties, who has been disabled from birth, reflected on her teen years: "They were depressing; mostly because of my situation, of wondering how I was going to turn out. I had to prove that

I was the best student in the school, the best at everything I did. My parents expected it, too; if I came home with less than 85 per cent in any subject, the roof fell in. It all hit me when I got to high school. The second year, I fell apart, and I was in hospital for weeks. I went to pieces from all those years of trying to be so good, to be the perfect student...." Her voice trailed off, and she stared down at the table.

"Trying to be too perfect is a 'perfect' way of ending up in hospital," I said gently.

"Yeah. I learned that," she admitted with a wry smile. "When I got out, I'd had enough of perfection. I finished the year, then I quit school."

As Patty talked, I had been thinking about the others who'd tied themselves in knots aiming for perfection. That drive is one of the greatest dangers the disabled face, and I will explore it more deeply when I look at these women on the job. The need to compensate for one's less-than-perfect body can have disastrous consequences.

Chronic embarrassment is another factor that works against the disabled student. Sarah provides a clear example. Her bladder is paralyzed and an allergy prevents her from using an indwelling catheter, which would stay inside her body, held in place by a small balloon, and constantly drain off her urine. Instead, she must insert a catheter every few hours, removing it immediately. If she fails to do so on time, she gets wet.

In a school situation, this can cause unbearable emotional agonies. "When I go back to school this year, I'm worried about going to the bathroom," Sarah confessed. "Before, I've gotten wet twice, right in the middle of class. I didn't hang around with those kids, and they didn't know about my bladder problem, even though the teacher did. Oh, my God — that was *so* embarrassing."

There are two solutions to this problem. One is surgical: an operation called a ureterostomy bypasses the bladder, diverting the flow of urine through a small hole in the side,

where it is gathered in a lightweight appliance that adheres safely to the skin. This is a drastic measure, to be performed only when absolutely necessary. And Sarah is beginning to think it *is* a necessity for her; that it's vital to her emotional well-being. At least it would give her the freedom to leave the house, and to stay out as long as she wishes, without fear of an accident.

A far simpler solution would be to inform able-bodied children, from a very young age, about the vagaries of a paralyzed bladder. This is one reason older, more experienced paraplegics are beginning to go into the schools. They're telling students about all facets of disability, and so far, the children appear to be responding well. If nothing else, this idea could serve to make embarrassing explanations easier. I'm sure Sarah would not have been so mortified had her class-mates understood. Then she could have shrugged the incident off with a joke. The cruelty of children is frequently due to lack of information; once they know the facts, they're usually pretty good about disabilities.

At least girls like Sarah are now being integrated into the high-school mainstream. Special classes end at grade nine, in Nova Scotia and disabled children are moving into regular schools. However, integration can have unexpected effects, as Didi was quick to discover.

Didi has a genetic condition called osteogenesis imperfecta; the substance that binds bones together is lacking in her body. At twenty-eight she's the size of a five-year-old, and some of her bones are quite deformed. She has normal sensation and movement, but the weakness in her bones restricts her to a wheelchair. Didi is what one might call a character. Happily extroverted, she doesn't consider herself disabled, and when she told me of her move to a regular school, there was a mischievous twinkle in her eyes.

"Academically, I didn't do well; not because I didn't have the capability, but because it was another world. It was so interesting, socially; it was so much fun to go with the

other students, to skip classes, play cards, or go out for a cigarette break. It was much more fun than sitting in class, listening to the teacher."

Others lacked Didi's adaptability, and knack of forcing the able-bodied kids to overlook her wheelchair and consider her one of the gang. Some of the women I interviewed found mainstream schools intimidating and cold. Frightened and shy, they lagged behind the confident able-bodied students, making themselves cope — or appear to cope — for one year, then they dropped out, still longing for the protective atmosphere of their old schools.

As for physical considerations, the transportation system still needs improving. Speaking in 1982, after her family had moved back to the city, Sarah was disgusted. "The wheelchair bus we've got now is impossible! It's old and rickety, constantly breaking down. Last winter we had no heat for three weeks, and one day recently, the ramp got stuck halfway down. They had to lift us on and off. The kids with cerebral palsy, who don't have much control or co-ordination, are strapped in with one flimsy seat-belt."

Even more worrisome for Sarah, the bus is always late. Every day she misses part of her first class, and the teachers are getting upset. "We're supposed to get new buses soon," she concluded, "but heaven knows when they'll come."

In this day and age, with more and more disabled children attending mainstream schools, one would think that high schools would be renovated to make them accessible to those in wheelchairs. Ramps, wider bathroom doors, elevators to upper floors: all are essential. In 1983, only one Halifax high school was equipped with an elevator. Another has had an elevator shaft for years, but the mechanism and car have never been installed.

Sarah attends that single accessible school. In 1982, one of her classes was located in an inaccessible wing. To accommodate Sarah, the principal ordered the class moved.

All Maria's courses are on the first floor of her new school, but in junior high, she ran into too many steps, and a principal deficient in tact or empathy. "I had to go up thirteen steps to my English class....They wanted me to *crawl* up the stairs, and to have someone just carry my wheelchair after me."

And yet, it's not always wise to be carried, as Sarah pointed out: "Once I had four guys carrying me up to my typing class, and they suddenly burst out laughing. I looked at them, and I noticed their eyes were all weird. They were high as kites, stoned! They nearly dropped me three times."

It's a wonder any of these kids make it all the way through school. No wonder many give up. On the other hand, after having the importance of education drilled into them from primary days, a surprising number — the vast majority — persevere.

Several of my respondents chose to complete their educations via the General Educational Development course (G.E.D.), frequently known as The Equivalency. The course is taught in city schools, and the diploma granted is purported to be the equivalent of grade twelve. However, it isn't really equivalent. I've taught the course to my literacy students, and it's a five-part survey: grammar, literature, math, social science, and science. Short excerpts from the classics and poetry comprise the literature section, each one followed by a multiple-choice quiz. The other parts are made up of problems, with multiple-choice answers. Although the course does help develop deductive reasoning, it's no substitute for three years in high school. However, most universities accept the G.E.D. diploma for entrance, and that's where many disabled individuals begin to spread their wings.

Chris and Cindy explained how, for them, the G.E.D. became the "Open Sesame" for the university gates. "We were told to take it," said Chris. "Then we said, "What if we go to school this summer, and try to take a course? If we get good marks, will you look at them, and the G.E.D. test results, and decide on that basis?"

Smilingly, Cindy continued, "They said we could qualify for their first-year program. So we took the G.E.D., and passed with high marks. Chris took two summer courses, and made B+'s in both. I took one and made an A. That's when we were told the university accepted us!"

A year later, both girls are A students. But what if there had been no G.E.D., no way to prove their abilities? Would they have had to wait until they reached twenty-five, in order to qualify as mature students? Would the drive to learn, which had outlasted so many frustrations, have continued to burn as strongly?

Chris and Cindy are not the only young, disabled women grateful for the existence of an equivalency program. Stella, a tiny women of twenty-four, with a rare genetic deficiency, survived until grade five in the school system, then took two years of correspondence.

"But I had no teacher to help me with it, and I tried to do it myself, she said. "They kept sending it back, saying it was done wrong. I never knew why, and I just got really discouraged. Now I'm living in the city, going to vocational school, and I'm studying to write the G.E.D., to get my grade twelve. I started in March, and now — in August — I'm about half-way through. My lowest mark has been 90 per cent so I guess all the studying's paying off."

However, months, Stella complained that the hours required for the G.E.D. classes were too long, and that by the end of each section, she's forgotten what was studied at the beginning.

She would like to go back to correspondence. Now she wants to work on her own, but she can't afford it. "To get a diploma by correspondence requires sixteen credits, which is an awful lot of work, too. And it costs $45 per credit. I'm on social assistance, and they won't pay it, so I guess I'll have to keep on with the G.E.D. I wish they could devise a course that's half-way between the two." Stella would like to see a course where she could go to school two or three days a week, then continue to work on her own the rest of the time.

Susan is currently taking an upgrading course, a common

approach for those with little or no formal education. If she continues to do well she, too, could eventually qualify to write the G.E.D. She wouldn't be the first to expand her education from nil to a grade twelve equivalency, in just a few short years. I dare say she will not be the last.

For those who do not have the ability or desire to continue to university, completion of the G.E.D. fulfills another goal. It does wonders for a woman's pride, polishing a self-image tarnished by circumstances beyond her control. I heard that dignity, that self-respect, in several voices when, in response to my question, "How much education do you have?" they were each able to answer, "I have a grade-twelve diploma!"

Then there are the training courses: classes in secretarial skills, computer programming, and so on. The vocational skills taught in these courses are usually more marketable than the majority of degrees and lead to responsible, if not exciting jobs. Unfortunately, many potential students don't know what courses are available, or where they can go to take them. Others complain it's too difficult to keep up with the pace of the work, and a few say no course is available in the field they want to pursue.

The latter problem may be solved by on-the-job training, but disabled individuals applying for these training positions have to be careful employers don't take advantage of them. For example, a training course in small appliances leaves the student with a valuable skill, but fast-food chains have been known to hire disabled people, claiming them as trainees, just so they won't have to pay minimum wage. (On-the-job training courses carry "allowances" — usually very small — rather than salaries.) And it doesn't take a year to teach someone to cook hamburgers!

*

When I went back to college, I was particularly worried about the attitudes of the professors. The thought of prejudice against the disabled didn't concern me as much as the fear of being singled out for special treatment. However, I was lucky;

this situation never materialized. One teacher did not appreciate having me in his class, but he was used to teaching male students, and I always felt he wasn't impressed with any female, disabled or not.

With my fellow students, I admit that, in the beginning, I overdid the independence ingrained in me since rehab, where we'd been taught to do everything we could for ourselves. I wouldn't even let my class-mates open doors for me. Then a friend observed I was acquiring a reputation as a snob, that my class-mates would open classroom doors for any female, and that if I wanted to remain in their good books, I had better let them pamper me just a little.

Alarmed, I quickly reconsidered my priorities. Independence at *all* times had been drilled into us at the rehab, but did that mean I should struggle for ages, fighting a heavy door, while five able-bodied men stood there watching? I told myself that as long as I did my own work, without special favours, I could probably afford to let them make life marginally easier for me. With a sigh of relief, I learned to relax and enjoy myself. I spoke with several disabled women who attended that college, and all of us agree with Didi's opinion of the prevalent attitude on campus: "It's very gentle, very understanding." The entire population made three physically difficult years much smoother, and I will always be grateful for their kindness.

Before her accident, Alison, a quadriplegic, had dropped out of a women's university. Today she's enrolled in the now co-ed St. Mary's, and she's just discovering the charms of the campus. Alison lives in residence with a friend, who doubles as a personal-care attendant. Eventually, she would like to go into counselling, but for the moment, she's studying psychology.

I asked her how she found her professors and fellow students. "Great!" she answered, grinning. "They can't do enough for me."

"Do they try to do *too* much?" I asked.

"Yeah. They wanted me to take tests home, but I refused. I want to do it in class, like everybody else. They give me extra time, but if I'm going to make a mark, I want them to know I did it without cheating, or without taking all night. One teacher assigned an essay to be written in class, and she told me I didn't have to do it. I said, 'But I want to. I want to try. I've got a writing splint, and I'm just going to sit here and try to do it.'"

The professor meant well, but what she didn't understand was Alison's need to see if she could manage on her own. If she couldn't, then she would have been forced to accept assistance, but she's a proud young woman, and she had to make the effort.

Carol, who has been blind from birth, attended a large, co-ed college, and at the time, she relished the professors' willingness to bend over backwards. "They spoiled me rotten," she admitted wryly. "If you're bright, you can get away with a lot. Too much, really. I have never been disciplined about deadlines. I would go to my professor, and tell him I didn't think I could get this paper done on time. He'd say, 'Oh, that's all right, Carol. Don't worry about it.' So I'd get it done whenever I got it done."

In retrospect, Carol feels she should have been made to meet the same deadlines as the other students, and that the lack of discipline was bad for her. "Somebody should have put his foot down," she said.

The illnesses and hospital seiges that took their toll in elementary and high school don't disappear just because their victims have entered university, although at this level it's not as traumatic to go back and pick up the pieces. In elementary and high school, "older" appears to imply "stupider". However, mature students are common in all college courses, and that inhibiting feeling of being older than everyone isn't likely to cramp one's style.

Still, drop-outs exist, and I'm forced to confess I'm one. Spinal meningitis cost me the seven credits of my first year,

and a serious bout of bronchitis neatly snatched the six of my last from under my nose — three weeks before finals! In between, my chronically low blood pressure restricted the number of courses I could handle, and after five years, I was getting nowhere, fast. I decided I'd had enough. Thoroughly fed up, I spent two aimless years wondering what I really wanted to do. Then in 1969, I suddenly had the urge to begin writing again.

I was plotting a novel, when a friend in Los Angeles sent me an old television script, which she hoped I would find "amusing". Amusing? I zipped through it, thinking, this is *it*! This is for me! Then I realized that I didn't have the faintest notion how to construct a dramatic presentation, so it was back to school again, this time to an adult-education play-writing course.

Eighteen months later, on January 2, 1972, I was notified that the producers of *Marcus Welby, M.D.* were interested in buying an autobiographical story-line I had written. Evidently, they had wanted to do a segment on paraplegia for some time, but all the ideas they'd received centred around men in veterans' hospitals. They believed the average person could relate more easily to a young woman's sudden illness and its after-effects. My outline sold while the others gathered dust. How fortunate that I had a ready-made outline in my own life!

Well, some of us may take a fearfully long time, but we get there. Eventually. It just takes perseverance, patience, and the odd stroke of luck.

All hassles, annoyances, and disturbances aside, five of the women who began their school lives disabled made their way through at least one degree each. Dr. Brandt is retired from psychiatric counselling. She's a published author and a gifted inventor, who designs and builds amazing aids for the disabled (including her own wheelchair, which includes a heating and cooling system, and a toilet!). Doris is a retired teacher, who got her first job during World War II, a time

when very few disabled people were employed at all, never mind in the field of education. Carol works for the federal government; Lynn is a consultant for a major corporation; and Nicky, who was born without arms, is a lawyer.

There are other well-educated women in the group I interviewed, but these five struggled with disability-related problems from a very tender age. *And they won.*

At the moment there is a determined set of a dozen students — in local high schools and universities. These are young women determined to acquire not only diplomas, but those all-important practical abilities. Half of them hope to become counsellors, agreeing with Maria when she said, "If you're going to be a counsellor for the disabled, you should *be* disabled." Two would like to teach, Chris is interested in the law, Maria in day care.

For every question in the interview, I had at least one unexpected response. The query about future plans was no exception. "I'd like to be a teamster," said Jean, clearly enjoying the stunned expression on my face. I wouldn't be surprised if she made it; she has the tenacity for it as well as a knack of capturing the humour in every situation.

Reading through the interviews, I perceived a pattern emerging from the diverse comments on education. Those who survived the first year of high school and passed, without becoming too depressed and discouraged, appear to have found within themselves the spirit and stamina to finish. It seems that after that crucial year, all things became possible; as if the grade ten pass had bestowed energizing shots of encouragement and self-confidence. Did an inner voice then say to them, "You've got this far. Now — onward and upward,"? I wonder.

I firmly believe that all physically disabled children have the same potential as able-bodied youngsters, and that with full integration of the schools, accessible buildings, improved transportation, and specialist tutors, they can succeed as completely and convincingly.

Lovers and Other Strangers

Before I began interviewing in earnest, I called on Dr. Brandt, asking for help in formulating questions and in deciding which problems most needed discussing. One by one, we thrashed through the areas of concern, and at the end of our conversation, she concluded that, on the whole, she thought disabled women had an easier time integrating into society than disabled men. However, she felt there was one area of exception: "I think women have the disadvantage in dating and mating. I think it has always been the traditional role that women were the nurturing ones who took care of the helpless — children or wounded knights. I think there are probably many more disabled men who marry."

Since I knew only three disabled women well, and they were all married, two of them with children, this theory was new to me. I had never considered my own marriage as anything out of the ordinary, and I was surprised to realize it might be. However, within the first three weeks of the interviews, I was forced to concede that Dr. Brandt had a valid point; the women I was meeting were unmarried, and few had been involved in close relationships. I talked to forty-five, and only five, myself included, had husbands. Two were widowed, nine divorced, and two engaged, but when I totalled the number of women who were either virgins, or who had not had a sexual relationship since becoming disabled, I found

a staggering 50 per cent. One-half of those women said, "I've never had a boy-friend," or, "Not since I've been disabled."

No wonder many said, "It gets lonely."

<p style="text-align:center">*</p>

On the day I was wheeled into rehab, I, too, was a virgin. I had been dating for a couple of years, but in the early '60s, good girls didn't go all the way. Particularly not clergymen's daughters. A little necking and groping around in parked cars marked the limits of my knowledge. When I contracted meningitis, I had been seeing someone regularly, and he came to the hospital, where my parents smuggled him into my isolation room. Gowned and masked, he stood there, tears streaming, as he told me how much he loved me, and that I must get better for him. I didn't see him again for a year, and then only once.

Fortunately, I hadn't been terribly fond of him; he was a nice guy, my parents approved of him, and we had fun together, but I wasn't deeply attached to him. When he dumped me for another, he hurt only my pride. I forgot him once I was allowed regular visitors; one of my biology class-mates began coming to see me, and while he was just a friend, it was nice to have the attention.

Then came that unforgettable night in rehab, when there was no room for me at the women's table, and I had to sit with four men. Half-way through the meal, I glanced up, and there was a husky, handsome blond staring at me: Bert, my big fisherman.

I couldn't take my eyes off him; the magnetic attraction between us was stronger than anything I'd ever known. He was gorgeous, his huge blue eyes quite irresistible. One of the young nurses, more sympathetic than most, noticed the exchange, and for two weeks she played matchmaker. Bert gave her a message for me, usually something insane, like, "Sit with me at lunch?" and she delivered it, asking if there was any reply.

After a few days of this, Bert was instructing me in the fine art of kissing, and I was more than happy to let him correct my mistakes. I was discovering how much more sensitive my mouth had become, and I knew the extra feeling was more than just the result of his expertise. As our relationship progressed, I encountered the same increases in sensation of my face, neck, and breasts; my ears became so hypersensitive they were painful. Bert had a single room, and once I was allowed to stay up all day, we spent every free minute there. The nurses and therapists never bothered to knock, but if they walked in on a kiss, they were more inclined to tease than to criticize. However, when it came to watching for doctors, we were more cautious; they weren't as sympathetic towards young people caught in a frightening new world of wheelchairs and unresponsive bodies. One resident angrily told my mother, "I saw him kissing her!"

If he expected Mom to fly off the handle, or to wonder what her usually circumspect daughter thought she was doing, he was sadly disappointed. Months later, she told me, "I said to him, 'Leave them alone. They need each other.'" As usual, my mother's instincts were unerring; she understood *perfectly*.

Anyone who becomes disabled and is forced to confront the realities of rehab life, can be expected to form ties with someone who shares the experience. It's extremely important that one continue to regard oneself as a sexual being, capable of attracting and holding affection. A rehab romance frequently becomes the rope by which one hangs onto one's sense of self; it's a safe, harmless relationship that can perform miracles on a wounded ego.

However, a grievous lack of information seriously inhibited Janice, Ann, and me. We had no idea what our bodies could or could not do, and no one was willing to give us any guidance. We were too afraid to ask questions about our own sexuality, and no hints were offered. We were left to puzzle it out for ourselves. In 1981, Alison found this backward, prudish attitude towards sex unchanged. "One doctor had a

little talk with me," she said, "but I didn't feel he was comfortable discussing the subject."

And Monica's physio told her, "We're not *allowed* to discuss sex with our patients. We do, but we're not supposed to." I don't know why a physiotherapist, who's been treating disabled bodies for her entire professional life, is not permitted to discuss those bodies with their *owners*. That notion doesn't make one scrap of sense to me.

But since I've heard about that ban, old riddles are resolving themselves in my mind. In 1964, I didn't understand why those young women, most of them in their twenties, never mentioned the subject to three teenage girls desperately in need of help. We were all friendly, and all had favourites to whom we became very attached. Living and working in close confinement, we chatted about every subject under the sun — except one.

Inevitably, Bert and I sought the privacy necessary for experimentation, but we never felt safe from intrusion. I managed to chart the undamaged areas of sensation and locate those areas becoming hypersensitive. By comparing ourselves to blind people whose hearing develops beyond normal, partially compensating for the loss of sight, we were able to figure out *why* the uninjured parts of our bodies were reacting so strangely, but neither one of us could guess what those changes might mean in terms of possible orgasm.

The last week he was there was sheer hell for both of us. We had been talking about getting married some day, and that brought all our frustration to the boiling point. "I want to ask you," he declared, "but not unless I know whether or not I'll be any good for you. If I can't be a real husband, forget it."

Naturally, that set off arguments as to the definition of a "real husband". I was taking it all terribly seriously, but looking back, I realize he knew, deep down, that it would never work. I was too caught up in my romantic dream; I couldn't see the insurmountable differences between us. He could,

but I think he wanted to put them off, to hide them away, for just a little while longer.

As that week flew by, he became morose and moody. He'd been talking to the other male patients, and some claimed they could achieve erections. Others couldn't, and a few didn't know. Bert, assisted by his nearly normal sensation, had no problem with arousal, but... "I'm scared it won't go anywhere. I guess I could find out for myself, but I'm too chicken." The pain in his voice was unbearable to hear. I began to wonder if perhaps I might help.

The night before he left, my favourite nurse was on duty. She agreed to let me stay up late and brought Bert's pills in very early. Turning to leave, she fixed me with a long, hard stare, then she went out and switched off all the corridor lights. I got the message; we could count on her to leave us alone.

Still, I feared an unscheduled visit by a doctor and was petrified. Pushing thoughts of climbing into bed with Bert out of my mind, I concentrated on my plan. Shaking with fear, I asked him to turn out the lights....It took a long time, and my inexperience kept getting in the way, but he finally reached orgasm. Holding me tightly, he sobbed out the nightmares of a year in hospital.

Before I returned to the ward, we were engaged.

It lasted all of three weeks. His first letter was brief (he'd told me how he hated writing), but loving. In the second, he said, "I won't mention the word love, because you won't believe me. It just won't work."

I was crushed, and once again it was my mother who came to my assistance. With the relationship severed, she could tell me everything she hadn't mentioned while he was there. Did I realize just how unalike Bert and I were? She pointed out the differences in our backgrounds, educations, religions...all the potential problems she'd seen, and which I had allowed myself to ignore. Slowly, painfully, I began to

understand, and in time, I was able to put Bert behind me, sealed away in my heart under the label "First Love".

I wouldn't have missed knowing him; my one regret was all the sneaking around we'd had to do. To this day, I wonder what those doctors were afraid of. If we'd had a few minutes' each day, when we could have been assured of privacy, I wouldn't have considered stealing into labs or endlessly riding elevators. It was a *bad* situation, and I hate to think that other young people are still devising ways and means of being alone.

There were films on sex available for men in 1964, but they were never shown in our rehab. There were even a couple of books, but again, these were written strictly for the males. I saw one of the books, when it was too late to help Bert and me; a nurse slipped it to me, then scurried away. However, I was disappointed. The volume devoted only one paragraph to disabled females. That snippet claimed that women are better suited, biologically, for sex without normal sensation; that we don't have to depend on nerves for erection, or muscles for orgasm. Now, I'd long since figured that out for myself. I didn't need the authors, a quadriplegic and his wife, to tell me how my body was built! Their poor little paragraph was about as useful as if they'd said, "Lie down and be quiet."

Today, there are some excellent books for the female disabled. Two are particularly helpful: *Female Sexuality Following Spinal Cord Injury* (Elle Friedman Becker, Accent Press, 1978) and *All Things Are Possible* (Yvonne Duffy, A.J. Garvin and Associates, 1981). For Alison and others, these volumes answered most questions. However, I don't believe it's right that doctors leave such problems to be solved solely through reading books. As Dr. Brandt said, "I think disabled women should know, very frankly and very early, what the meaning of sexual function is in regard to disability. I think they may need a little coaching with regard to dating, and so on. I only wish that more rehab doctors, particularly psychotherapists, were female."

No doctor can tell a paraplegic girl exactly what will happen to her, sexually speaking. A doctor is unable to know how every inch of her body feels to her, or how she will react to various stimuli. What a doctor can and should do is to advise her of possibilities, even probabilities. He can set some expectations, define parameters. If he can't — if he finds the subject too embarrassing — I think he could easily instruct the young nurses and therapists, who are always with the patients, to tackle the subject for him. I'm sure the young physio who teased me unmercifully about Bert could have sat down and talked to me. We were good friends and it could have been painless for both of us.

Fortunately, some doctors do not find discussing sex with their disabled patients a problem. And there are rehabs where full psychological support is offered to the patient *and* her family, where counselling is available for the husband or lover. Unfortunately, the women I interviewed had never known such vital assistance. Two found gynecologists willing to help; the rest have learned by trial and error, or they still haven't learned.

Leaving rehab, armed only with Dr. Johnson's, "Sex can still be rewarding", and "You can still have children", I was angry. It was as if he had betrayed my early faith in him. I was seventeen, paralyzed, but healthy, definitely curious...and *scared*.

But at least I hadn't received emotionally damaging responses to my shy queries. Marsha wasn't as fortunate: "In rehab, I was the only female, so there was no woman with whom I could share those types of feelings. So I approached a female intern, thinking she'd understand I had a problem. I asked, 'Can I still have children?' — which *wasn't* what I wanted to know. She said, 'For God's sake woman, they didn't sew that hole up!' That was it; I asked no more."

Shannon also received totally inappropriate advice from a professional. In Birchwood, her nursing home, the young people had a woman from the Muscular Dystrophy Association come in to speak to their group. Shannon reported, 'She told us that the only way any of us could ever have sex was

alone, in our rooms at night." I suspect the Birchwood authorities were trying to discourage sexual activity within the home, but to accomplish their purpose by telling those young people such a bald-faced lie strikes me as highly unethical. Shannon knew better, but like Marsha, she never asked again.

*

Several of my younger respondents complained at length about the difficulties they encountered in meeting eligible men. I was fortunate in being able to evade that problem; attending an all-male university provided the perfect opportunity to make contact with every imaginable type. The first morning, I was recruited into typing and distributing student I.D.'s. What a chance to meet all eight hundred at once! Mentally, I filed away interesting faces for future reference.

About eleven, I looked up from my typewriter to find a pair of bright blue eyes under a blond crew cut regarding me quizzically. He smiled at me, a frank, lopsided grin, and I was immediately drawn to his warmth. Others had stared at my wheelchair and seemed uncomfortable talking to me. Crew cut wasn't interested in the chair, but in the woman sitting in it.

I had to know his name, so I glanced at his I.D. application: W.R. Matthews. Briefly, I wondered what the initials stood for, but in the crush of students waiting for their cards, I soon forgot all about him. Besides, he wasn't my type, or so I told myself.

A few days later, I entered my first English class. Already I had a horror of being on display, so I headed for the back of the room. I wasn't hiding myself, but neither did I wish to invite stares and questions. I found a desk, turned it sideways so I could reach it, crossed my legs, so as to appear more "normal", and waited for the professor to arrive. Nervously, I looked around to find out if anyone was gawking at me.

Someone was; but it wasn't that what's-with-you? stare I was just getting used to. Instead, I saw that friendly crooked grin. Crew cut! I couldn't remember his name, but again,

I appreciated the way he was smiling at me; no one could have taken offence, least of all an edgy young paraplegic.

When the lecture started, I couldn't hear the professor. Glumly, I told myself I would have to move up front, like it or not. Next class, I was right beside Dr. Anders' desk. And who had moved up with me? W.R. Matthews himself. Bill. I thought he was just being nice, but in the days and weeks that followed, we became fast friends, going to class together and sharing lunches.

That first year, I went to all the football games and dances, even though I didn't enjoy the latter; I still couldn't bear to watch anyone else dance. But one night, Tiny, a chubby, fun-loving senior who'd helped me through the fears of the early weeks dragged me, wheelchair and all, out onto the dance floor. My protests fell on deaf ears. "You don't need legs for this...stuff they're doing now," he announced firmly. "You've got your head and shoulders, your arms, and your hips. Let the beat take over; just *move* with it! Have fun, and to hell with anyone who wants to stare at you!" No one could resist Tiny; a few moments later I was shaking it up with the best of them. My brain and body hadn't forgotten and it was wonderful to bust loose. Tiny roared over the music: "Told ya!"

Dances began to be fun once more.

I always saw Bill at those evenings. He was going with a woman named Beth, and he always brought her over to talk to me. Sometimes it must have seemed to anyone watching that Bill and I were the couple, Beth the outsider, but I made nothing of it.

Apart from college activities, I deliberately kept my world small. I went to classes, then straight home. I had to; the level of physical pain was rising daily, and by the time I had sat through my lectures and labs, I was exhausted. I spent most evenings doing assignments, then I shut myself in my den and turned on the stereo. Already I'd learned the best way to handle pain: distraction. Music had always taken

me out of myself, and if I could just forget the aches and hurts, it was easier to recharge my batteries for the next round of classes.

On weekends — aside from dances and football — I went to movies with friends, shopping with my mother, and I had begun to date a little. For a while I went out with Kerry, one of the boys from my chemistry class. We were just friends, but that was fine by me; I'd decided I didn't want a serious relationship. Not just yet.

In the end, teenage insensitivity on Kerry's part spoiled the friendship. "My friends are going to think I'm nuts," he said one night.

I asked why.

"For going out with a cripple," he replied easily.

That did it! I'd heard that word in rehab and my instant reaction had been total revulsion. No one would ever call me "cripple" and get away with it. Kerry didn't mean to hurt me, and he couldn't understand why his companionable date had turned into a grim-mouthed harpy. And I was too shaken to explain.

The reason I was so upset was because we had been warned in rehab to be on the look-out for men wanting to date disabled women for kicks, or to win bets with their friends. Intellectually, I knew Kerry wasn't like that, but I couldn't come to terms with my own fears once they'd been aroused.

Sarah's mother lives with those same fears constantly. "I worry about her, about how she'd cope," said Jane. "One of her nurses told me that when Sarah got a little older, boys'd start taking bets on whether she could or couldn't have sex. I'd never considered that, and I told the nurse she was crazy, but she said, 'No. Be prepared for it, because it's going to be one hell of a big hurt.' Now I'm really leery."

I'm sure my mother was, too, and for her sake as much as mine, I'm glad I never met that type of man. And yet, when I brought home the young men I did see, I wonder if her thoughts corresponded with those described by Jane: "A boy

she likes has come here, and I'm wondering, why are you doing this? You're a perfectly nice, able-bodied, good-looking boy; you should be going out with other girls instead of taking Sarah across to the pool hall. I really look at those boys suspiciously, then I ask myself, am I reading in something that's not there? Am I taking away something that is? Oh, Lord, it's terrible. It's terrifying."

Worries over the intentions of daughters' dates are frightening enough for any parent, but for the parents of disabled daughters whose psyches are already battered and bruised, such fears take on monstrous proportions. If my mother was troubled by those dreads — and I'm sure she must have been — she never communicated her concerns to me. For that restraint, I bless her. Talking openly about such jitters would only have reinforced them for her, and inflicted them on me.

Yet, in the back of my mind, I too was afraid of the men my rehab physio called "the creeps". I had to learn to judge a man's intentions, to decide whether or not to risk being used and hurt. If I was going to make mistakes, I had to make them on my own. Men who are out for cheap thrills are not the figments of some overprotective mother's mind; the creeps who take advantage of disabled women do exist and sometimes the world's best judgement won't help. Maria was twelve when her brother's closest friend began raping her regularly. He attacked her when she was in bed, unable to get to her wheelchair. He was eighteen, and powerful; she didn't have a chance. She was too afraid to tell her mother, with whom she was not on the best of terms, and when, six years later, she finally did accuse the boy, her mother refused to believe her. The fellow was a model of perfection, married, with children. He wouldn't do such a thing! How dare Maria spread such lies!

In 1981, Maria told me, "I can't go home again. I tried once, and just like always, it happened. I grew up with that guy; he was like my brother. As far as I'm concerned, it was incest. I don't know if I'll ever get over it."

Of those who've had the choice, who've been able to pick their dates, and decide how far to let the relationship progress, I think Noreen best explained the attitude we've had to cultivate: "I'm very protective of myself, and I'm not going to get myself into awkward situations that I can't get myself out of. I think, too, that I'm not just looking for a guy; I'm looking for a very open-minded person. I think....Well, you have to be friends first."

A few weeks after I stopped seeing Kerry, I was at a dance with a student who was going to be a Roman Catholic priest. He told me honestly that he merely wanted the experience of going out with women in order to counsel teenagers effectively later.

As usual, Bill and Beth were there, but they left early; to me it looked as if they'd had a spat. My seminarian had a report to finish, so I went home with girl-friends. We took our time, stopping for a bite to eat, and when we finally drove into my driveway, I was astonished to see Bill standing on the steps. I sent my pals in ahead and went to see what he wanted. I was thoroughly mystified.

"Can't a woman tell when a guy is crazy about her?" he demanded.

What???

His voice softened. "When I first saw you, I thought, I could love her. Well, now that I know you, I do. I've broken up with Beth."

I was *stunned*. It had never occurred to me that he might be feeling more than friendship toward me. In that instant, my own I-don't-want-a-serious-relationship attitude shattered. I'd constructed a shell around my emotions, little guessing I was already deeply involved. That meant that it wasn't very difficult for him to persuade me to take a chance, and within three weeks I consented to wear his football pin.

My greatest worry was what Bill's parents were going to think, but whenever I asked, he shrugged his shoulders and mumbled something incomprehensible. At New Years', I met them.

His mother and father were never openly hostile to me, but I could sense their deep disapproval and disappointment. In retrospect, I realize they must have been terribly dismayed to contemplate someone in a wheelchair as a future daughter-in-law. No one had prepared them for that possibility. But then Bill didn't deliberately set out to fall in love with a paraplegic, just to upset his parents. Unfortunately, when he met me, he got the wheelchair thrown in.

In the beginning, he and I could have exercised a bit more tact; we could have allowed the serious nature of the relationship to dawn slowly. I would have preferred it that way, but once his brother, who was also at SMU, told the family about the pin...that was that.

In later years, I came to love his parents deeply, but in those days they were afraid. The state of my health must have been of grave concern to a mother watching her eighteen-year-old getting in over his head. They must have worried that I'd be a burden on their unsophisticated son. However, they made one crucial mistake; they underestimated the strength and adaptability of that son. And while they must have frequently felt he was being perverse, I wondered if they realized he really did love me.

Fortunately, my parents were delighted. Bill and my mother became very close. When she died the day after my grandmother, and Dad was too numb to help me, Bill carried me through that hellish time. In fact, my mother's last words were for him: "Take care of them."

I don't know if any of our parents realized the agonies of indecision *I* experienced in the two-and-a-half years we were going together. Was I really doing the right thing, for either of us? Should I break it off? I confided my fears to Bill, but he wouldn't listen to such "foolish talk". Did I *want* to marry him? Well...yes! Once again, I permitted myself to be persuaded.

Besides, I hadn't believed the doctors who had told me I could live a normal span. I convinced myself that something else would go wrong; that I'd be dead of kidney disease, or

some such, by the time I was thirty. I eased my conscience by thinking, if it got too much for him, it wouldn't be for long.

When our fellow students learned we were engaged (which we made official after he came home from a summer stint with the navy in 1965), the reactions upset me deeply. They didn't say too much, but then, they didn't have to; the looks on their faces spoke for them. I caught the odd one glancing at Bill strangely, and I felt I could read the thoughts: What's wrong with him? Why'd he dump gorgeous, healthy Beth for *her*? Marry a girl in a wheelchair? And so on. It was terribly unsettling.

Several of the people I interviewed mentioned similiar attitudes. "I think men have a funny attitude towards disabled women," said Carol. "I can go into a bar and sit there, all by myself, and nobody ever thinks I'm trying to get picked up. I might be, but no one would ever think a nice girl like me would do such a thing. People automatically assume you're a saint."

In short, able-bodied men tend to think of disabled women as sexless. As neuters. Why should someone like Carol, who can't see, or someone like me, who can't walk, be interested in sex? When people realize we are, they're shocked speechless. Their attitudes can lead to incidents no able-bodied girl would experience.

Carol provided the perfect example: "I was working for an organization that helps people in trouble by giving them someone to talk to. I once spent an evening in a church basement, all by myself, with a rapist and exhibitionist from a provincial jail. He never bothered me at all; we had a nice conversation. Then I left, and what did he do? He went out and exposed himself to a pack of Brownies!"

Chris and Cindy were twenty and twenty-two when I met them; two handsome, witty young women. And yet they complained that there are too few able-bodied males capable of seeing a disabled female as a girl-friend. "Neither of us has ever had a boy-friend," Chris frowned. "It's hard to

believe that this could ever be, but it's something we're never going to experience, and we've become very pessimistic about it. I think a sexual relationship is just fine for a disabled woman, but if it can't be standard sex, then it goes very much against society's code. And that's just *assinine!*"

Most of the women I talked to can engage in "standard sex," but for those whose deformities make positioning difficult, or for whom intercourse is painful, alternatives exist. The more I interviewed, the more I became convinced that the majority of these women do not consider intercourse their highest priority. On the whole, it's the human contact that is missing from their lives; they need someone to hold, someone to talk to, someone to comfort them when they're depressed.

Several of my respondents expressed the opinion that mature men are more understanding, more accepting of a woman with physical problems.

At the age of twelve, when she had just started to make friends with boys, Julia broke her neck in a diving accident. In the mid-forties there was no rehab; disabled people automatically became "shut-ins". Julia spent twelve years at home; then she came to Halifax to take courses and, hopefully, to go to work. Julia went to dances and parties with a group of friends, most of whom were planning on meeting men there. "Once in a while, a fellow would come over and talk to me," explained Julia, "then turn around and ask the girl next to me for a date. It was just a means of getting acquainted. I was thirty-five when I met the first man I could feel close to. That's a long time to wait."

Many times during the course of my research I was asked, "How did you find someone that accepting that *young*?" I'm not sure, but I suspect that while the majority of the understanding men do seem to be over thirty, there are a few in whom maturity has little, if anything, to do with chronological age.

Still, Chris was right; there are "too few" in their late teens and early twenties — as Patty discovered to her regret: "He seemed very accepting of my condition, but then he became less and less so. He would take me to a party, and then get mad at me because I couldn't dance. Our relationship ended when he wanted to take another girl to a dance. He said, "I'll come back and see you tomorrow, but I just need to go." He would never dance with me in my wheelchair. That's when I gave him his ring back."

Patty's problem was another woman — her sister. "I think sex and the disabled woman is perfectly normal," Patty told me. "But I know some nondisabled people don't. Like my sister! I told her about some relationship I'd had. Stupid me; I should never have shared it with her. She just thought it was yech, icky, really awful. I guess she figures disabled people just don't have those desires."

When I was planning my wedding, I felt I was being patronized by some of my friends. It was suggested I keep the ceremony small and informal; perhaps I might wear a nice suit.

No way! For years I had been dreaming of a big wedding with all the trimmings, and with a long, traditional gown. I wasn't going to let something as inconsequential as a wheelchair rob me of my fantasies. I was twenty, reasonably pretty, and very much in love. I decided that a few stuffy, squeamish people weren't going to bother me. With the help of Bill's mother and younger sister, I picked out a beautiful formal dress. I was mad that I had to compromise on the veil of my dreams, but I didn't want yards and yards of tulle halting the procession by tangling themselves in my wheels. Grumbling and cursing the chair, I compromised on a shorter arrangement.

*

The night before the ceremony, I was again assailed by doubts. I thought we knew what we were doing, still, the

problem I'd carried since rehab hung heavily on my shoulders. What did Dr. Johnson's, "Sex can still be rewarding", really mean? I had yet to find out.

Bill and I were both living at home, with parents whose moral philosophies were very strict. I was leaning more to depending on my conscience than on the dos and don't's learned at my father's knee, but I couldn't quite break away from the "good-girls-don't!" attitude. In a way, I was dreading that first experience; we could have found time to ourselves, but I was putting it off. Simply, I was afraid.

What kind of a wife could I be? I didn't doubt my ability to love. (Then — as now — affection was the most important emotion in my life. That trait has sometimes caused me problems with people who don't understand, who find me too affectionate, but...I can't help it!) I thought I could learn to take care of a home; I could even cook! I wasn't the least worried about being a companion. We'd been so close for so long, and beneath the romance ran a solid foundation of friendship.

I realized I wasn't afraid of Bill, but of sex itself. I had very little vaginal sensation, and no movement in the muscles. I had some action in my hips, but was it enough? I'd already promised myself that if orgasm proved impossible for me, I would content myself with pleasing him and that would be sufficient satisfaction for me. But...*could* I give him that much?

If I had to live my life over, I would have had all my questions and fears answered before I married. At the very least, I would have known what to expect! As it was, I went to sleep that last night as a single girl wondering, what I would do if I were a total flop as a partner.

The next morning, on August 26, 1967, Bill and I were married with all the pomp and ceremony only my "High Church" father could conceive. Far from the suggested small wedding, we had five bridesmaids, a Naval Guard of Honour, and three extra priests to help Dad officiate. The service was beautiful, if too long (and I barely remember it).

That night, the worst of my fears disappeared; Bill seemed perfectly satisfied with my abilities as a partner. As for me, I felt warm and emotionally fulfilled. I couldn't believe the sensation of being loved, for myself, *as I was*. I was at peace, telling myself that Dr. Johnson's "rewarding" was a fair definition.

However, I was young, and I wanted the physical joys my friends had told me about. I don't *think* my motives were purely selfish; I also craved the ultimate feeling of oneness with my husband. I prayed that someday — I hoped soon — we'd find that total expression together. I assured myself that millions of inexperienced women before me had taken time to "get it right". That was a great comfort; I'd wait a while before panicking.

All the days and nights of our honeymoon, we played together. We knew we had to experiment, to search out the areas of my body where sensation was strongest, to find positions that would be most effective for me (both in terms of feeling and movement). Most of all, we had to develop the communication between us, to learn to tell each other what worked best. We knew we couldn't be afraid to *talk*, to ask for what we thought we needed, to complain if something felt uncomfortable.

And we had to learn to laugh at ourselves. When a couple is searching for a pleasurable position, and one party asks, "Dear, would you please pass me my left foot?", without laughter it could be terribly embarrassing. And what about the unexpected spasm that slams a knee into a new husband's ribs? If we hadn't seen the humour in those situations, I would have been in tears.

One afternoon, when we came back to our cottage after sightseeing, we decided to lie down for a *nap*, and perhaps because I was relaxed, not even thinking about love-making, the spontaneity of the occasion caught me unaware; I was too tired to think, "What comes next?"

Then suddenly, I was on fire, the already hypersensitive feeling in my upper body tripling, every nerve awake. From the beginning, I'd had some vaginal sensation, plus a fair feeling of movement and pressure. But in that instant, I could have sworn every inch of sensation was 100 per cent *normal*. If it wasn't, it definitely felt so to me, and while I was surprised, I was too delighted to puzzle it out. For the first time, everything felt *right*!

Then the spasms hit. The thought ran through my mind that it was only my bladder acting up, but all I cared about was the movement those spasms were supplying to my vaginal muscles, compensating for the paralysis.

I felt myself carried higher and higher, and then, at long last, the tremendous, overwhelming sensation of release and relief. The sense of belonging, of becoming one entity with my husband, was beyond anything I'd dared to dream. I remember the wild, crazy thought: if that wasn't what I was looking for, it will surely suffice!

Satisfied, my body glowing warmly, I kissed my delighted husband. Then I noticed the dark red splotches on my chest and shoulders. Hmm...the manuals I had eagerly pored over before the wedding had referred to "orgasmic rash". The thought that the marks on my upper body corresponded exactly with that description made me insufferably smug. No longer did I envy those disabled women with normal genital sensation. I could function quite well on what I had.

However, I soon learned this wouldn't happen every time I wanted it to. Often I would be properly aroused, thinking I was well on my way, and then...nothing. It seemed almost as if I was losing my place, and any distraction made me lose my train of thought. I tried to get back on track, but once the feeling was gone, it couldn't be recaptured.

For ten years I had no idea why or how any of this was happening. In 1978, a long-overdue book was published: *Female Sexuality Following Spinal Cord Injury*, by Elle Becker (Accent Press). I had guessed that my mind was doing

most of the work, and that the hypersensitivity in my breasts had been setting it off, but nevertheless, it felt wonderful to have my theories explained and expanded fully.

I had worried for years that I was imagining everything, and when I finally read that the feeling of normality bestowed by the brain is something tangible, I was tremendously relieved. I think I had been afraid I had been talking myself into orgasm; that my body wasn't really responding the way I wanted it to.

Like any other women, I've had my sexual disasters. From 1976 until 1979, I was in such pain that Bill could hardly bring himself to touch me. I protested he wasn't making it any worse, but he knew I was lying. One night I couldn't help screaming, and that did it. Afterwards, we were very careful, scarcely daring to try.

Then, when surgery eliminated most of the pain, it also took a lot of my feeling. Oh, dear! When I realized I was going to have to attempt to function on half the sensation in one breast, and 90 per cent in the other, I was dreadfully depressed. "This is going to be like cooking a four-course dinner on one burner," I growled to myself.

However, the capacities of the human brain never cease to amaze me. Eight months later, my mind had become attuned to the reduced feeling and was picking up the load accordingly. I had heard of quadriplegics claiming orgasmic capabilities, but I hadn't quite believed their stories. I do now. Due to the way my mind has been trained, I think that even if I lost all sensation from the neck down, I could — somehow — make up for such deprivation. One thing's for certain…I would give it one hell of a good try!

*

As Bill and I began married life, I started to detect a shift in the attitudes of the able-bodied public. Where their reactions had been, what does he see in her? and, what's wrong with him?, now they changed to an approach that was even more patronizing: what a fine fellow; see how he takes care of her!

This attitude can really damage an independent spirit. I resented it in 1967, and today I'm even more adamantly opposed. I've had friends who should know better come up to me and say, "He's a fine man. Aren't you lucky to have someone who takes care of you so well?"

Come *on*, people; give a person a break! I think he's a damn good guy, too; I'm his Number One fan. But apart from the few days I've been critically ill in hospital and the nurses haven't known what to do with me, he's never taken care of me. I'm quite capable of looking after myself, and if anything should happen to him, I'd survive on my own. I might not like it, but that's another story.

People have never accepted us as any other married couple, and should I live to see the day they do, I will be indescribably surprised. If I'm on my own, and people discover I'm married, nine times out of ten their *very* next remark is, "Do you have kids?" I'm well aware of the question behind the question: they want to know if ours is a sexual relationship.

I would much rather forget my three miscarriages, but I'm forced to drag them out, to admit we tried. In fact, we tried for four years, despite my gynecologist's attempts at dissuasion. I had gone to see Dr. Jannings for a prewedding check-up, and I said I'd heard I could become pregnant. "Yes, you can," he confirmed, explaining that the hormones which produce ovulation were dependent on glands and the blood stream, not on the nerve impulses of the spinal cord. He wound up this little speech with, "The problem with your having kids isn't getting them here. It's what are you going to do with them afterwards?"

"I've adapted to everything so far. I'd find a way to manage," I promised.

He wasn't convinced, but to give him his due, once he realized I was determined, his nagging ceased. At least he wasn't attempting to deny me the right to try to have a child. Dr. Jannings saw me through my first miscarriage, becoming

a kind, sympathetic friend. If he was relieved I'd lost the baby, he didn't insult me by saying so.

For weeks after that miscarriage, I remained tired and listless. "You need a check-up," said Bill, and I agreed with him. Rather than trouble a busy gynecologist with a general practitioner's job, I called one of the specialists working with the disabled, asking if he knew of someone who'd take a patient in a wheelchair. Some won't.

Dr. Landers showed me just how rotten doctors' attitudes vis-à-vis their disabled patients can be, particularly regarding sex and child bearing. I patiently explained that I had recently suffered a miscarriage, and he warmed up by announcing I shouldn't have children, period. "By the time they'd be five or six, you'd have them doing so much fetching and carrying they'd hate you, and by the time they reached their teens, you'd have no social values to pass on to them."

I was stunned: I didn't believe I was hearing this. "Wait a minute," I snapped. "I have a normal marriage, and my husband and I are hardly social outcasts. We go everywhere and do everything other couples do. I may be a paraplegic, but you're treating me like a cripple!"

The distinction escaped him; he continued as if I hadn't spoken: "If your husband ever tires of a paraplegic wife, you must be understanding," he said glibly. "You should encourage him to seek company elsewhere; help him find a nice mistress."

I had to get out of there; I didn't trust myself to answer him. Bill was waiting for me, and the instant he saw the wild expression on my face, he wanted to know what was wrong. I'm sure he thought I'd heard some dire diagnosis. I didn't tell him what had happened until we were almost home. I knew him well enough to predict his reaction and to put distance between us and Dr. Landers. And I had been right to wait; he was all set to drive back and give that bastard a piece of his mind, if not his fist.

Other women have encountered similiar attitudes from members of the medical profession, although caring doctors

who treat us as people do exist, the time has come to speak out against those who are either uncaring, or downright sadistic in their relations with the disabled. That day in Landers' office, I was struck by the thought, if *doctors* feel this way, it's no wonder average people react the way they do!

*

There is yet another segment of society that appears not to believe in sex and the disabled woman; the husbands of some of my respondents didn't think their wives (or, by the time I reached them, ex-wives) should be indulging.

At age twenty-two, Monica graduated from college in June, married in July, and was diagnosed as having multiple sclerosis, a progressive disease, in August. One weekend she went blind, but after several weeks in hospital, the drugs her doctors prescribed restored her sight. Then the disease attacked her legs, and for a couple of years she stumbled around: "Like a drunk; falling down, getting stupid little bruises, never really hurting myself, but...."

Before her disease finally went into the remission she'd been praying for, it left her in a wheelchair, a paraplegic. I met Monica a few months before her thirtieth birthday, and I saw a sensitive young woman who has been deeply scarred, emotionally, as the result of the events in her life. I asked how her husband Bruce had reacted to her disability.

"He was very concerned about how it would affect his life," she said tonelessly. "About how it would affect him. He was concerned for me, but he kept thinking about what we had ahead of us."

Monica believes her husband's basic selfishness manifested itself almost immediately only she didn't recognize it as such. As her disability progressed, his attitude became more obvious! "He'd go out for hours, staying away from me. I met very few of his personal friends."

"Do you think he was ashamed of you?" I wondered.

"Who wouldn't?" she shrugged, "But he always came up with excuses, like, "That place isn't accessible", and "You

wouldn't feel comfortable with those people." I guess I was pretty good at accepting excuses."

"I think we all do that, to some extent," I temporized.

"It was comments by other people that brought home what he was like," she continued. "A girl who worked with him who knew that he was married, and that I was his wife, called about a Christmas party. She said, 'I'll probably see you there.' I don't think she realized I hadn't heard about that party from him. I didn't say anything until the night it was held, then everything came to a head. He said he wouldn't be comfortable with me there, and he knew it wasn't accessible. But then, at the time I was getting wet from bladder spasm, and that embarrassed him. Besides, since I didn't know his friends, he felt he'd have to spend all the time with me."

Monica said that early in her illness, Bruce appeared not to realize it was a degenerative condition, and that psychiatrists had found it impossible to talk to him. He pretended to know everything about the situation, so they left him alone. He was good at the glib replies that satisfied their queries.

Monica didn't do well with psychiatrists, either. "I was very excitable, so they put it off. It was as if they thought, she'll accept it after a while."

Between the blindness and the year of stumbling around, Bruce was still making love to his wife. However, just before she entered the wheelchair, the sex stopped, "abruptly". I asked if Monica thought the lack of counselling in rehab contributed to the problem. "Yes," she said firmly. "I think that because I had had a psychiatrist, they assumed it was all taken care of."

"Did anyone ever ask if you'd had any advice?" I probed.

"No."

"Did anyone ever volunteer?"

"No. No one even gave me books. They just said, 'Go home and have a nice weekend with your husband.' That weekend was like being with my brother, and for two-and-a-half years after that Bruce never touched me."

Four and a half years after the morning she went blind, Monica could take her life with Bruce no longer. They shared a house, but they weren't living together as a couple.

Finally, Monica told Bruce she was leaving. He appeared relieved: "I wouldn't have brought the subject up first," he told her. "I'd have stayed with you as long as you didn't."

"How noble of him," I snorted.

"I think he hoped to get through to me quicker than he did," she replied, tears trembling in her eyes and voice. "I guess I'm very slow. But when you love someone, you tend to be."

"Do you still love him?" I queried gently, although the answer was plainly etched on her face.

"Yep." It was a small, sharp sob. "I can't turn it off."

When she moved into her own apartment, a separation agreement was drawn up. Monica showed it to me, and as I scanned the first few lines, anger surged through me. In the bluntest terms it stated that Monica had MS, and could no longer fulfil her duties as a wife! While she had asked for the legal separation, she had never expected to see it couched in those words.

Even though Monica left her husband, physically speaking, I include her name with those who were deserted by their husbands at onslaught of disability. I don't feel there's any doubt that Bruce deserted her emotionally and sexually. He stayed in the same house with her, but he had left her in spirit.

Since striking out on her own, Monica has met another man. In the beginning, she wondered why he came back to see her, time and time again; all they ever did was talk. And then he explained.

"He thought he was safe," she told me. "He thought I didn't have any sexual feelings; that his own fears of impotence would never come into the conversation. I wasn't threatening to him.

"I shattered that image one night," Monica grinned mischievously. "Remember that conference on sexuality we had?

I told him if he'd been around when I got home from that, I would have raped him. That startled and scared him." He didn't remain scared very long. One night, he stayed, and he discovered that with Monica, he wasn't impotent.

National statistics inform us that when men become disabled, 50 per cent of marriages break up; for women, that figure is 99 per cent. After disability, the majority of young men marry; only five of my respondents have taken the trip down the aisle. Four of those unions remain intact. Five of my respondents were married at the time they became disabled; four of their husbands deserted.

*

For months I listened closely as my respondents discussed the attitudes of the able-bodied, particularly those of able-bodied men, and as they talked about their personal needs, feelings, and desires. But as they began to address their fears, I sensed I'd discovered another factor that separates these women from their able-bodied sisters. For the first time, I looked at the attitudes of disabled women to themselves.

I wondered why Didi, so small and deformed, could run around high school with a trail of able-bodied boys in her wake, and why Andrea, whose disability is easily concealed, should sit at home, alone. Why did Janice and I have several fellows asking us out when so many others said, "I've never had a boy-friend?"

Slowly, a partial answer emerged: a number of the women I interviewed have difficulty being accepted as women because deep down, they don't accept themselves. What a painful conclusion!

A couple of fiercely independent types aside, these women would love to be involved in male-female relationships, but too many of them simply don't know how to relate to men; they don't know where to begin. They've been different, segregated, since birth, and they've never learned to make social contact with the opposite sex. Either they don't know

how to let men know they're interested, or they go over-board at the slightest sign of attention, frightening men off. And then there's the most inhibiting problem of all: they're afraid. Of men, and of sex.

Everywhere I went, all but two of those disabled from birth said they'd received no counselling. They were invariably filled with curiosity; the first time I noticed eager eyes fastening on my rings, I prepared myself for the questions to come. I wasn't disappointed: the moment I switched off the tape-recorder, I heard, "Can I ask you some things now?"

In some sessions the queries were straightforward; in others, I could read the questions in the expressions on my interviewees' faces. Several times, I seized the chance to find out what they'd gleaned by way of the grapevine.

"I know how to go about sex," Sarah admitted. "But I don't think the back seat of a car would be such a good idea. If I went into spasm, I might decapitate the guy!" She thought for a moment, then added, "I have so much damned spasm; I'm scared it might get stuck!"

Laughing with her, I told her that in my experience, spasm was more of a help than a hindrance, and that should she find herself too tight, she'd just have to hang on and wait for the muscles to relax.

Far less amusing were the talks with women whose deformities have made them ashamed of their bodies. Stella confided, "My skin's so ugly. I keep myself covered up to the neck all the time." She was afraid that a man, seeing her skin, might change his mind in a hurry. I was once afraid of turning someone off, and I know how agonizing it is.

This kind of fear — the worst of all — frequently stems from two lifelong preoccupations: bladder and bowel vagaries. Paula, a spina bifida paraplegic in her mid-twenties, complained, "I have a urostomy, and the appliance sticks to my side. I'm afraid it might come off...you know, during something."

I told her I'd had that surgery when I was her age, and it had bothered me far more than it had Bill, who brushed off my worries as much ado about nothing, but Paula was unconvinced. "Listen," she said frowning, "some mornings I wake up, and I've had a bowel movement. I don't think a guy would like that."

Probably not, but there are men who don't give a damn about natural functions. Paula scowled and mumbled that too-familiar sentence: "But there aren't many. Not enough to go around."

The following week, Sarah stated her fears bluntly: "I'd die if my bladder gave out and I peed on him!" Even with a totally accepting man, that *is* an embarrassing situation. Once it happens, it never quite leaves the memory, and it tends to inhibit future encounters. That's one reason why it's *imperative* for a couple to cultivate a sense of the ridiculous.

Now that I've gone through all the interviews many times, I've reached the tentative conclusion that those of us who have been able-bodied, at least until our late teens, probably have the advantage where dating and mating are concerned. It's not that we're any more attractive; rather, it's that we've had the opportunity of being just one of the gang. We are, perhaps, a little more likely to know how to handle social situations, how to talk to men, how to build relationships.

For those who have learned to cope, despite genetic disabilities, the deciding factor for this side of life appears to be the same as for any other; those who succeed in relationships are usually those whose families encouraged them to get out and meet people, to seek counselling, and to develop their sexual identities.

In rereading the interviews with those who have become socially integrated, an interesting sidelight emerges: women who have known solid relationships say that one real romance works miracles for the ego, even if the partnership doesn't last.

Lynn explained: "I went out with a guy for two or three years, and it was pretty serious. I broke it off; he was a very kind and generous individual, but the mental element wasn't there for me. But I think it was very therapeutic, because it brought me to a much more integrated picture of myself as a physical person."

Myrna, a genetic paraplegic of twenty-six, showed me the same picture from the reverse angle: "I wish I could meet just one guy. I don't necessarily want someone to sleep with, although that would be nice. But I want someone to hold me, to tell me I'm okay; someone to care for me as I am."

I can't help being concerned about those who seem to have no self-image whatsoever, because self-esteem is the foundation for all human dignity. They struck me as being terribly lonely. The glimpses they offered of their lives were stark and bare, bereft of affection. Their attitudes toward the able-bodied are frequently poor, even unjust, but they are the result of segregated lives, of the lack of parental warmth and direction, of skimpy counselling and misinformation. They've grown up unschooled in the barest social skills.

Dr. Brandt said she wished more rehabilitation doctors were female, and I believe she had a valid point. Many of the women I spoke to could benefit immensely from candid counselling, and I think female doctors would be more empathetic and less embarrassed about the subject.

Few of these women would be able to ask even a female doctor intimate questions, and perhaps doctors sense that inhibition. However, all medical personnel are going to have to learn to raise the topic themselves. Doctors, nurses, therapists, and chaplains are going to have to look for the right time. They must recognize the interest, lead into the subject, and pursue it. The families of disabled girls would also benefit from their help.

I'm not sure how we're going to convince the able-bodied public of our sexual identity. Conferences will raise awareness, but people learn best on a one-on-one basis. I'm afraid

we're probably going to have to teach them, answering their questions even when we feel they're too personal. Sexual acceptance would appear to boil down to the same components as acceptance in school or on the job. *Everything* comes down to information, understanding, and integration.

Bringing Up Baby

In all the days and nights of rehab, the single most encouraging thing I heard was, "You can still have children." Having lost so much, I could scarcely believe there was one normal body function I could hope to experience.

When Bill and I were married, we planned to have a family. My obstetrician-gynecologist suggested the pill, but we both wanted children right away; we saw no reason to delay. A year passed, and apart from a few late periods, there was no sign of pregnancy. I was beginning to wonder if the rehab doctor had had his facts straight.

But after twenty-two months, the unmistakable symptoms appeared. I identified them within a few days of conception, yet it was eight weeks before the lab tests agreed with my body. I was ecstatic, and Bill seemed just as pleased. We spent hours arguing about names, while I pored over catalogues, looking at infant clothing.

The euphoria lasted exactly one week. At the beginning of my pregnancy I'd had a little bleeding, but my doctor could find nothing wrong. I made myself forget the alarming spotting.

One night, just as I was getting into bed, I started hemorrhaging. Bill rushed me to the hospital, after three days of the terrifying diagnosis, "threatening to abort", I lost the baby. A student nurse was stunned to find me sitting upright in bed, in shock, staring at the fetus in my hand.

That was the only time I've ever seen Bill cry. "I was scared I was going to lose both of you," he admitted.

The second attempt at becoming a mother was a duplicate of the first; it lasted nine weeks and ended with me in hospital. There was only one difference: an intern delivered the fetus. He told me it was half the size it should have been, so I began to wonder why I was miscarrying. The doctor answered, "It's not because of the paraplegia. One in five pregnancies ends this way; it's nature's method for ridding the body of a malformed embryo."

When I asked what caused the malformation in the first place, he said he didn't know. I have my own theory, and the doctors I've spoken to don't rule it out. I blame all the chemicals I absorbed over the years, all the drugs I was given to try and stop the pain. In any event, pregnancy number three went the same way. Then the doctors said, "Enough!" A tubal ligation was performed.

Trudy was twenty-nine, divorced, and a single parent when she experienced her first attack of multiple sclerosis. When she recovered sufficiently, her doctor also recommended a tubal. However, a few weeks before, she'd been advised she had a uterine infection and was temporarily sterile. Trusting the doctor, she didn't think to take precautions. Then, just before she was scheduled to have the tubal surgery, Trudy recognized the familiar symptoms of pregnancy.

"Impossible," said her doctor. "But just in case, we'll do a D and C". He didn't want her MS to be stirred up by a pregnancy; she was doing so well, and the strain would be too great. Both operations were performed at the same time, and Trudy went into anesthetic shock. "By the way," said her doctor, "you weren't pregnant." Trudy was certain she had been, but she was too ill to argue.

When she was released from hospital, she began to realize the symptoms had not abated. "My body still thinks it's pregnant," she reported. Her doctor showed her the report from the surgeon: negative.

"As time went on, I began to notice I was getting very swollen from not having my period," Trudy told to me. And I remembered how she'd complained, "If I'd only get my period, I might feel better." Even then she'd been wearing loose clothes, muttering that none of her pants fit. I asked if she'd felt movement. "Yeah. I thought it was gas moving around."

Returning to her doctor, Trudy said, "Look, there's so much pressure there, and I've never gone this long without a period. Either I have a tumor, or I'm pregnant!" The doctor decided to examine her.

"All I heard out of him was, 'Oh, Christ!' He yelled at me to get my clothes on, then he was out in the hall, babbling incoherently to a nurse."

Realizing how upset the doctor was — and why — Trudy began to cry. "I thought of all the drugs, x-rays, two operations, one of which was deliberately meant to kill the child, the other a tubal so I wouldn't get pregnant. My doctor came in, sat down, and he said, 'What do you want to do? This was supposed to have been rectified. I can't help you; you're past the time for a therapeutic abortion.' "

When the surgeon scraped Trudy's womb, she was two weeks pregnant. Somehow, he missed the fetus. I reminded her how upset she was when she first called to tell me what had happened. "I was. I mean, God damn, it was terror and shock....I had to sit down and explain to Joanie, my twelve year old, all about abortion and birth defects; I was thinking that after all that, something had to be wrong with the baby. Joanie'd never heard the real, hard facts. Not like that. I had to tell her what could be wrong with the baby and what could happen to me if my MS was affected. I could have ended up in a wheelchair."

Fortunately, Trudy is one of the strongest young women I've ever known. Once the initial shock had worn off, she pulled herself together and began to think about the baby. She had all the tests, and the results showed the baby was alive

and kicking. Joanie accompanied her mother to an ultrasound session, and she was delighted to see the image of the baby. On the way home, she turned to Trudy and said, "We got arms and legs, Mom. When you stop to think about it, what's a couple of fingers and toes? Anybody can do without those. We don't need to worry any more."

Trudy was greatly cheered by Joanie's accepting attitude. Still, she was concerned; what if the child should be blind? "All I could think of was a little helmet for his head," she remembers brooding. "There's a device that scans a page for Braille letters. I know I could get that, and there are other aids."

And Trudy swore that no child of hers would ever be sent to the school for the blind. "If it's blind, it's going to mean a lot of extra work, but I won't have a typically blind child! I don't want one who can't function in the real world. I don't care who I have to fight...to put it in regular school. I don't want any disabled child of mine in special classes, and I don't want it on that bus for disabled kids. I saw a mother carrying a little blind girl into that school, and I thought, why are you taking her in there? Teach her outside those walls. I wondered if the child even knew how to walk outside the home."

Despite her fortitude, Trudy had an extremely difficult pregnancy. She became toxic and the baby kicked continuously, until she complained she was sore all over. Her MS gave her less trouble than expected, but some days her legs were numb and she had problems with her balance. We talked at length about the baby. Trudy insisted her fear of its disability was not selfish; that she didn't want it to be disabled for its own sake, not for hers. She simply didn't want her child to experience the segregation and cruelty some of her born-disabled friends have known.

The last few weeks were terribly tiring. Trudy saw the doctor every couple of days and she never knew if he would put her into hospital. Had her MS flared badly, he would

have ordered a cesarean, but as long as she remained reasonably well, he wanted her to try to carry it to term. The day the baby was due to be born passed without as much as a cramp. A week later, labour was induced.

That evening, exhausted but ecstatic, Trudy called. "It's a girl...and she's just *perfect!*"

After months of agonizing worry, a happy ending. But the story is only beginning. Now Trudy has two children to care for — and she still has MS, a progressive disease.

Moira has been a paraplegic since she was twenty (another car accident). Fourteen years later, she is happily married with two children, Cheryl, nine, and Danny, three.

Moira and her husband, Dan, were another couple who waited a long time for their family; they'd been married four years before they discovered Cheryl was on the way. At that time, they were living in Montreal, and Moira's doctor had had past experience with pregnant paraplegics. He told her that if she wished, they could take her straight upstairs and do an abortion.

"No way! Never." replied Moira angrily. Later, she realized what the doctor had been trying to tell her: "If I wanted the child badly enough — if I *really* wanted it — then I would go through with it and do exactly what he said."

She received the same advice Dr. Johnson had given me when I was pregnant; she was to watch her weight very carefully because the extra pressure of the baby could cause skin problems. She didn't need pressure sores; with a new baby in the house she wouldn't want to be stuck in bed while breaks in her skin healed. And she was to have her urine checked frequently; during pregnancy she'd be highly susceptible to blader infection.

Moira was also warned that labour can be swift for a paraplegic. We can't tense our abdominal muscles, even subconsciously, so the doctor urged her to get to the hospital with time to spare. Apart from the always irritating bladder infections, Moira's pregnancy was uneventful. She gave birth

to Cheryl easily. The nurses simply steadied her legs to control spasm, and the baby was born in the hospital bed. Six years later, Moira completed her family with Dan, Jr.

*

My own gynecologist had once said, "It's not getting them here I'm worried about. It's what are you going to do with them afterwards?"

Moira admitted that with her first child she was *constantly* worried. "You can't know how bad it was," she shuddered. "I had terrible nightmares. I could see another woman taking Cheryl in her arms, leaving with her, saying I wasn't capable of taking care of her. I'd wake up in a cold sweat."

I urged her to tell me how she's managed.

"When the baby's there, you have to, and I did," she replied. "Don't let anyone able-bodied tell you it can't be done, because it's not that bad."

How did she feed Cheryl?

"I breast-fed her, and whenever I picked her up, she screamed. She sensed I was nervous." The nervousness triggered bladder spasms, so whenever Moira held Cheryl, she always made sure she was near a table or sofa; she had to have somewhere she could put the baby down while she dealt with her jumping legs. As she became more confident, her emotions once more communicated themselves to her daughter. Cheryl stopped screaming.

"Were you ever scared of dropping her?" I asked.

"Terrified," Moira laughed. "To leave my hands free to push my wheelchair, I used to wrap her in a receiving blanket and carry her around in my teeth. Her body rested on my lap, and I just held the blanket in my teeth and wheeled. I even shopped with her that way, until she was old enough to sit in the cart. I carried her home like that, too, hanging my parcels on the back of my chair."

I thought this a rather neat solution, but Moira grimaced. "Other people didn't think so," she said. "They told me it

was okay for a cat and her kittens, but not for a human mother and her baby. My mother thought it looked awful, but I wasn't sitting back looking at us. I was just making sure Cheryl was properly looked after. When Danny arrived, I carried him the same way."

And what did she do when her kids started to crawl?

"A lot of times they were grabbed by the back of their sleepers till the fabric stretched to the limit," she answered, grinning. "Or they were brought up off the floor by a fistful of pyjamas. That probably didn't look too terrific, either, but again, I wasn't the one looking. I was the one pulling them away from the hot stove, sometimes by an ankle. Anything! To other people, it wasn't the way a 'normal' person would do things."

What happened when they reached walking age?

"My husband got me a harness and a rope. Then there were comments comparing Cheryl to a dog on a chain. She only got away from me once. The next afternoon, Dan bought the wood for a fence!"

Years ago, another paraplegic mother had told me how self-sufficient her young children were, and how they helped her to take care of them. I asked Moira if hers had done the same.

"Oh, they did!" she replied, smiling. "They'd stand up, feet between my legs, arms around my neck, and they'd hang onto me while I wheeled them around. My mother commented on how they seemed to know what was happening." I've seen Moira with her children, and I know she's as competent as any able-bodied mother. As problems arise, Moira and Dan sit down and work them out together. They've always found a way to manage. Her kids adore her, and I wish the doctor who told me my children would hate me could see that happy family.

When Isobel became disabled, her girls were both very young (twenty months and three weeks). Her first fear was that the baby would catch polio from her. Later, her husband

deserted. Following her stay in hospital, Isobel started her own business. "I didn't ever really look back," she said. "I was so determined I was going to look after my children on my own. I think the thing that bothered me most was that I wasn't able to *go* with them as much as an able-bodied person could."

How did she compensate?

"I feel that I made them very independent. Today I find that everybody's complaining that they're spending all their time driving their kids here and there. I worked hard *for* my children; I gave them dancing, piano, and singing. But they always went on their own. Sometimes I think I made them too independent, but in a way, I'm glad I did. I'm proud of them, very proud."

The divorced mother of a five year old when she became a paraplegic, Marsha also encouraged self-reliance.

"I stressed that she be independent at a very early age," Marsha explained. "The problems I encountered were ones like not being able to pick her up off the floor any more. And it's very frustrating to send your child to school alone that first day."

I hadn't thought of schools being inaccessible from a parent's point of view, and I urged Marsha to continue.

"A lot of schools aren't accessible," she said. "To get where you were supposed to go, to get to the teachers, that posed problems. I would say my daughter and I had to re-program ourselves: to understand where we lived; to rely on each other. That took time and patience — for both of us."

And there's Dot, a feisty woman disabled in two car accidents. She walks with a limp, one leg is shorter than the other, and she has arthritis and gout. She's usually in considerable pain, yet she raised her own two children and thirteen foster children, by herself!

*

Women with genetic disorders that might be inherited by a child, as well as those with severe progressive illnesses, are usually advised not to have children. Stella is one example.

"There are several reasons I don't feel I should have children of my own: first, I wouldn't want to risk inflicting them with the same disease I have; second, I would like to travel if I get the chance, and I'm not sure I'd like to be tied down for ten to eighteen years. Also, when my energy level is not the best, I don't think I could look after a child properly. But I like other people's children."

Sarah doesn't have a congenital disease, but would still prefer to adopt, and Patty said simply, "I think that because of all the hurts and struggles, I've become a bit of a loner. I'm happy that way." Motherhood is obviously not the best course for everyone, but for disabled females, who are frequently told they can't do things, it's reassuring just to know they *can* bear offspring should they choose to do so. What matters is the choice; the right to make the decision.

The afternoon I spoke with Noreen, I'd completed my questions on sex and motherhood and was moving on to the next area of concern. She stopped me, saying, "I'm surprised you haven't asked about abortion."

New to interviewing, I always seemed to miss something. Apologizing, I asked for her views.

"With ultra sound and so on, they can get a rough image of what a child's going to be like," she began, "and I think a lot of questionable things are coming up — whether, if a child is damaged, do we have an automatic abortion, or do we give the parents the option? I wonder...if I were born today, would I be given the right to live? That concerns me a lot. I wonder, when does it stop? Does it stop at the blind, deaf child? Does it stop because a child might limp? Does it stop at minor, minor brain damage? I just wonder where the cut-off line's going to be."

"You fear all imperfect fetuses might be aborted?" I asked.

Noreen nodded. "I think it reinforces the belief that a perfect child is *the* thing. If you don't have a perfect child, well, get rid of the disabled one now, and have a perfect one later."

Sighing, she added, "There'll always be disabled people through accidents. For their parents, if they've had normal children at birth, how are they going to handle it if earlier they've been told a disabled individual wasn't the thing to go with? For me, I value life so much that abortion's the furthest thing from my mind. Yet I find a lot of my non-disabled friends think, well, if I'm in a tight situation, sure. I won't even allow myself to think that way, I'm *so* against destroying life needlessly. I wonder how other disabled women feel about it."

I asked some of the younger women who might possibly face that dilemma. Not one said she would *never* consider abortion, but most admitted to mixed feelings. All appeared to agree with Trudy's fears: they wouldn't mind having disabled children, but they would be terrified for the children's sake. They would want to spare their offspring the problems they had faced.

Bernice gestured to her deformities. "No way would I ever wish this on a kid," she said.

*

Asked to pinpoint their greatest problem, many disabled mothers say, "Finances. Social assistance." For single parents who can't work, or who have disability pensions inadequate to their needs, life can be an overwhelming struggle to make ends meet.

When Trudy was first disabled, her daughter Joanie went to live with Trudy's ex-husband. No one knew how long that first attack of MS would last, or how much damage it would do. At the time, Trudy's disability pension of $300 per month allowed her to live with her mother, paying $200 a month rent, without applying for social assistance. "Welfare," Trudy bluntly calls it. Then she became pregnant and had to look for a place to live as her mother's apartment building would not admit babies. Besides, the MS attack appeared to be over and Joanie was coming home.

Today, Trudy's rent is $415, of which the government pays $115 (the remainder is covered by her small private income). Assistance also gives her $177, which has to cover everything else: light, heat, phone, clothing — not to mention food. For Joanie's support, Trudy gets $19.88. Before she became disabled, Trudy always worked, but sometimes her salary wouldn't stretch to cover her expenses. She knows all about the difficulties of raising a child on government assistance.

"If it hadn't been for relatives, most of the time Joanie wouldn't have had very much," she said. "There used to be second-hand stores around and we always went and got our clothes there. Joanie really doesn't know what new clothing is; for her to get something new is a very rare happening. She doesn't really mind because all she's ever had is hand-me-downs, but she gets so excited when she gets something new, all her own, something that never belonged to anyone else."

And is there enough money for food?

"Never," she replied grimly. "There are always little things coming up, and you have to pay for them. They have to come out of the food money, which cuts back on the groceries you can buy."

For example?

"This month I have a $65 phone bill because I didn't have the money to pay for it last month. That included a $25 connection charge. They allow $13 a month for the phone — out of the food money."

The evening I interviewed Helen, she told me how embarrassed her sixteen year old was to be on assistance, to have to get proof of visits to doctor and dentist. I wondered if Trudy had run into that problem with Joanie.

"No, I haven't. These days a lot of kids have parents on assistance — welfare, and with them it doesn't have the bad name it does with adults. Besides, Joanie figures that if I can't do something for her, she'll call her father."

"Does he send you any child support?"

"He'll be sending me $120 a month soon," she said. "That's better than nothing, but since it'll be taken *off* my assistance cheque, I won't really be getting any more."

"They subtract your disability pension, too, don't they?"

"Right. So that's $300 off, then there'll be another $120 for Joanie. Once they even docked me for family allowance! "They cut me back so far I ended up owing them and I had to pay for part of my drugs. I don't know what I'll get for the new baby, but it won't be much. I'll soon be cut back to almost nothing. I think they should look at it as, 'Look what this girl has going for her; we shouldn't have to cut her back so much.' "

I remembered that Helen said her daughter never had enough money for school supplies. How about Joanie?

"A lot of her teachers don't realize how it is," Trudy sighed. "They'll send Joanie home, telling her, 'You have to have this book, that scribbler, and those coloured pencils.' Sometimes they'll be doing things that require a child to bring in money."

What if Trudy doesn't have it?

"I'll borrow it from somebody so that she doesn't have to be segregated."

Would it cause serious problems if she couldn't scrape it up?

"Oh, yeah. I don't think it's fair that she can't do what everyone else at school is doing. I mean, if they have movies or class outings."

I'd met Joanie and been impressed with her quick intelligence. I asked her mother about college.

"That's something I'm never going to be able to do for her," Trudy replied. "Her father will probably help her out." Trudy's ex-husband has remained interested in his child's welfare, but Marsha's has not. Her daughter Hope is now seventeen; when she reaches her eighteenth birthday, the assistance for her will be cut off.

"She wants very much to go to college," Marsha said *and* to be able to keep her home after she's eighteen — I don't know if I'm going to be able to do it. If someone is going to tell me that my daughter can't live at home and be educated..." she broke off angrily. "Recently, I was told that when she turns eighteen, it will be her turn to support me. I told him, 'You talk about the propagation of generations receiving social assistance! I raised my daughter to believe she has to take care of herself, and I'll be damned if the day will come when I'll be an albatross around her neck. I'd rather be dead first.'"

Helen also told me about children having to leave home when they're eighteen, unless the parents can manage on reduced assistance; two of hers are already gone. "Assistance breaks up a home," she said, tears in her eyes. She went on to explain how a child who is working, but living at home, has to pay board. The board is then subtracted from the parents' assistance, reducing their cheque even further.

Listening to Trudy, Marsha, and Helen, it occurred to me that Christmas must be an extremely stressful time of year.

"At that time, Helen commented, "we get a credit voucher for one of the chain department stores, a $35 credit note to go down and get a little something extra. They wait till the second last day before Christmas, and the note is only redeemable at a particular store; you have to go all the way down there." The store she named is a very long way from her apartment. For those in wheelchairs, it is also inaccessible.

In 1980, the social worker didn't arrive with the voucher until late in the evening, on a stormy, bitterly cold night. Nevertheless, Helen rushed downtown, arriving at the designated store just before it was due to close. All the Christmas merchandise was gone.

In 1982, Trudy found Christmas even more distressing. "I couldn't even get a food voucher for Christmas dinner," she said quietly. "Other people I know who are capable of working, they got vouchers, gift certificates, toys from charitable organizations. But I couldn't get a thing; not even an

extra $5! I'd taken what little money I had and bought presents for Joanie, so we had no food in the house. We wouldn't have had Christmas dinner if my brother hadn't made it for us."

Just before her new baby, Dana, was born, I talked to Trudy, who was worried. She hadn't had enough milk to breast-feed Joanie; what if the same thing happened again?

"Simulac is $33 a case," she said, "and $1.69 a can. A case will last only twenty-four days. If I can get a doctor's note saying, 'This child has to have Simulac,' then I may be able to get it paid for. Otherwise, Joanie and I will just about starve; it'll have to come out of our food money."

Trudy's fears were justified. She was unable to breast-feed Dana, a constantly hungry baby whose sensitive stomach required a formula even more expensive than Simulac. Assistance allowed Trudy an extra $78 per month, which proved sufficient to feed the little girl.

"Just!" Trudy added.

When Dana is old enough, Trudy hopes to be able to return to some kind of employment. "I would like to stay home with Dana," she said, "just as I would have liked to stay home with Joanie. But I feel that by me being out working, getting us off welfare, I'll be doing my kids a bigger favour. I figure if you stay home collecting welfare for eighteen years, you're not teaching your children any sense of responsibility or achievement. They're just going to think they can sit back and live off welfare. I don't want that for my children."

Neither do the other mothers.

A House Is Not a Home

I harbour what could easily be the most dismaying thought of all: someday, I might have to go into a nursing home.

I first faced that possibility in rehab, when Fred, one of the young men, was expelled for alcoholism. He was a quadriplegic, with huge, open pressure sores; he couldn't possibly look after himself, and he had no family or friends willing and able to take care of him. He was moved into a nursing home, and a few months later, he committed suicide.

On the day he left rehab, it occurred to me that if my parents were gone, and if something happened to my arms, I, too, would have no choice; I would have to be institutionalized. Even though I knew nothing about life in a nursing home, the thought of losing my independence appalled me.

When I mentioned this to my respondents, some reacted even more violently, agreeing with Fred, and immediately talking about suicide. In Marsha's words: "If my condition were to leave me totally dependent on other people — institutionalized — then I would commit suicide. I'm not afraid of it, and I've the guts to do it. I simply don't care to be maintained that way."

Obviously, though, not everyone reaches for the sleeping pills at the thought of life in a home. When I looked at the list of names provided by a social worker, I found several whose addresses coincided with those of local institutions,

specifically Birchwood Nursing Home and Raintree Estates. I decided I'd better try to interview some of those people. I was curious to discover how they felt about their lives. Eighteen years after Fred's death, the thought of having to stay in a home continued to scare me, and I wanted to see if the reality had any bearing on my dire imaginings. Scanning my brief list, I chose three women at random. I'd never heard of them, and I hoped they wouldn't be too senile to interview.

When I made my first call, the gay, high-pitched voice coming over the wire was quite a surprise. Previous callers must have shared my preconceptions in considering nursing homes places for old people, because Wendy giggled, "I'm only twenty-four."

Wendy said she would gladly give me an interview. She would also ask a friend, Shannon, whose hearing impairment restricted her from using the phone, if she would speak to me. And although Wendy's room-mate, Stella, was away that week, attending a camp for the disabled, Wendy was quite positive she'd want to contribute when she returned.

*

It was just past six when the Access-A-Bus pulled into the Birchwood driveway on a quiet summer evening. My immediate impression was decidedly favourable. The building resembled a low, modern hotel, and the grounds were neatly mowed and spacious — even if there wasn't a birch tree in sight.

Inside the main door, the ground floor was sunny and clean, the nurse at the desk polite and helpful. The atmosphere was a little cold and impersonal; but on the whole, it seemed benign. Bland. Not a bad place to be, if you need constant care, I decided.

But when I got off the elevator at Wendy's floor, my nostrils were suddenly assailed by the unmistakable odour of stale urine. That wasn't so pleasant! And where had they hidden the sun? The narrow hallway was depressingly dark, claustrophobic, and heavily carpeted. The twill was too thick for wheels; it was hard going even for my strong arms

and would be impossible for those with impaired function. Such a dramatic change from one floor to the next made me uneasy.

I met Wendy in her room. A plump girl, appearing more seventeen than twenty-four, her motionless legs and slow, difficult arm function told me she was probably quadriplegic, and her deformities hinted she'd been that way from birth. She quickly confirmed these impressions, telling me she didn't know the name of her condition, or how she'd inherited it. "I just know all my muscles are too short for my bones," she sighed.

I noticed she was having difficulty looking at me directly, and I saw her eyes were seriously out of alignment, but her smile was open and welcoming. Backing out of my way, Wendy invited me in.

The room itself was quite large, but I realized it would not seem so when Wendy's room-mate was at home; two wheelchairs would make it tight, with little space to manoeuvre. And I was shocked to see there was no curtain between the beds; not even a privacy screen. This struck me as blatant disregard for human rights, particularly in a chronic-care facility.

The interview went smoothly, but throughout, I had the distinct impression that Wendy was holding back. She spoke with ease and relish when discusing her fiancé—a man with cerebral palsy, who was twice her age, but not in describing her problems.

When we had finished, Shannon joined us. Her genetic condition, Friedreich's Ataxia, is progressive, and after putting her in a wheelchair, with impairment of all four limbs, it then attacked her hearing and speech. Wendy volunteered to stay and translate: "Just in case you have trouble understanding each other." Fortunately Shannon didn't mind.

On that evening, Shannon was thirty-seven, with a sensitive face and beautiful strawberry blonde hair. In repose, her face took on the slightly abstracted appearance common

to people who are hard of hearing, but her mind was razor sharp. Her dry sense of humour penetrated easily through her speech impediment, and I had no difficulty understanding her. In just a few moments, I found myself liking her enormously.

"Living with old people all the time, your attitudes change," she said. "You begin thinking, 'What the hell,' because you always have people coming up to you, trying to make you do things you don't want to do. They have activities here. Fine and dandy for the old people — they conduct them like you're old and senile. But they have *nothing* for the young ones. They started a young people's group, but they said they couldn't give it the same scope they could the old ones' group, so they abandoned it. They had a young counsellor, but they fired him."

Shannon was becoming extremely emotional, and after Wendy's reticence, her candour was refreshing — and upsetting. I asked about the treatment of residents by the staff, and she answered, "They come around and talk to you as if you were some sort of senile old woman. Well, I may be middle-aged, but I am not old, and I am definitely not senile. I have no intention of being treated that way." Her angry voice dropped to a sad, tired note: "I spout off at the staff, but no one cares what I think."

Shannon had been at Birchwood six years, and her deep unhappiness was palpable. Quietly, I shut off the recorder... and both women started talking at once! Without the rolling tape to inhibit them, they filled my ears with their hatred of the institution.

They complained about the lack of privacy, which went far beyond the no-screen situation I had spotted. According to them, no one ever knocked, or closed doors. Shannon: "The first thing I see every morning is a naked male quad. He's across the hall from me, and when they bathe him, they don't close his door. I'm no prude, but I don't like looking at a naked quad; it's an invasion of his privacy, and of mine."

Then Wendy started in on the hopeless laundry service: "It ruins everything decent you ever send down. They lost all my summer clothes last year, and I couldn't afford to replace them."

At the mention of money, Shannon muttered something about a "comfort allowance", but I couldn't pursue the topic as my husband had arrived to collect me. He found Shannon fighting tears, and Wendy piping, "The staff has no understanding of the disabled — especially young people — and they really don't try."

I should have asked Bill to wait for me outside, but I didn't think of it. Shannon took one look at him, and burst into tears, telling me how much she envied me. If I could have kicked myself, that would have been the perfect time! As we left, I promised to return to interview Stella, and made a mental note to ask her about "comfort allowance".

Coming home to the privacy of my nice, normal life, I felt wretchedly guilty, and insanely relieved at not having to spend the night in that dismal place.

*

Stella recognized my research as her chance to communicate her problems to the able-bodied public, and she was ready and waiting for me. She had obviously been thinking carefully about the things she wished to pass on; her words were organized, and scrupulously considered. Adamant about privacy, she asked Wendy to phone her fiancé from the lobby: "I'll be more comfortable if Gwyn and I are alone."

I was impressed by her manner and by her brisk, forthright replies to my queries about her early years. I watched her as she talked. She had a pretty face, with enormous velvet brown eyes, and caramel hair that would have been lovely if properly cut and styled, rather than chopped by unskilled hands. And she had a neat little frame, no bigger than a twelve year old's.

However, above her tightly buttoned collar, I could see the ugly sores resulting from her disease, epidermolysis bullosa,

a very rare problem. Stella was born without the top layer of her skin, and for twenty-three years the daily blisters had appeared. These had to be lanced, creamed, and dressed, then kept open until they healed. Her hands, normal at birth, had been so badly scarred from sores, and webbed from adhesions, that they resembled an amputee's stumps. At the side of each, a tiny, deformed thumb moved feebly. In fact, all Stella's motor functions were feeble; that was why she used a wheel-chair. She could walk, but only a few steps, and she seldom had any energy.

After we had finished all the background questions, I asked her about money. "It costs the government $1300 per month to keep each of us in here." (For those who have no means of supporting themselves — no savings, no pensions — the government pays for their room and board. In 1981, that amount was $1300 per month.) "The allowance for other things ranges from $20 to $50 per month, depending on where you come from; Social Services in some areas pays more than in others. If you're a smoker, you've *had* it! You're lucky if you can have a night out on the town for $20 today. Does the government think that because we're disabled, we're not supposed to enjoy ourselves? Aren't we supposed to associate with people?"

"Does that allowance have to cover other things, besides entertainment?" I put in.

"Oh, yes; clothing, all personal needs, and travel. They won't even pay for a cab to the doctor."

My mind reeled. "That's not much for a twenty-three year old woman to live on," I commented, feeling stupid at the understatement.* I was disgusted and didn't bother to hide the fact, but at that point I was more concerned with the general pattern of nursing home life, particularly as seen by the younger population.

"I'll tell you what it's like," she said softly. "It's like waking up at six or seven, to find a half-naked man or woman in your

*For more on this subject, see "Nickels and Dimes".

room. One thinks it's his room, and the other pulls off the covers, telling you to get up, because she thinks you're her daughter. With my former room-mate, it meant eating breakfast while she was on the bedpan, after the nurse had given her an enema."

Stella caught my glance at the ceiling. "Right. No curtains. There's one resident who hasn't got her mind, and the nurses claim they can't keep a diaper on her. When nature calls, everything goes on the floor."

Remembering that deep twill carpet, I resolved to watch where I was going when I left! I mentioned the now defunct young people's group, and Stella's eyes flashed. "Yeah. The administrator donated a room for the young people only, and we wanted to fix it up with lamps and books — like a rec room in a private *home*. We put catalogues in there, but someone tore them up; we had a lamp, but one gentleman smashed it. Last fall we had a bake sale to raise money for the group, but the social worker took the $300 we made, and dumped it into the general activity fund."

"Was that legal?" I asked. "I mean, if you raised the money for yourselves...?"

Stella shook her head, sighing wearily. "Someone wanted to call Legal Aid, but most of us are afraid of that social worker. She's done a lot of underhanded stuff, and we were afraid she'd cut off our money, tell the nurses not to take care of us, or curtail our privileges. Most of the residents are too scared to band together."

It occurred to me that perhaps some concerned citizens should "band together" for them. I didn't know what to say. By that time, Wendy and Shannon had come in. "We need help," said Wendy.

"And we need it *now*," echoed Shannon.

It had been many years since I'd felt that helpless. I could commiserate with them all night, but all I could give them was moral support. Or was it? "Tell you what," I said, thoughtfully, "I don't have access to any funds, and I can't pull any strings within the government. But I *can* help you tell your

stories. I can go out of here and talk about what you've told me, to anyone who'll listen."

I was almost sorry I had spoken; the hope on their faces was pathetic to see. Then I remembered I had wanted to ask Stella about the quality of the nursing care, a subject both Wendy and Shannon had ducked the week before. "What's it like," I queried.

"Rotten," she replied curtly. "There's not enough of it. One gentleman has multiple sclerosis, and he has no control of his bowels. One day he had an accident, and he sat there close to two hours, waiting for them. He had pressure sores, and I'm sure that didn't do them any good." It probably made them worse; infection is a constant danger to anyone with breaks in the skin.

That night, Stella went down to wait for the bus with me, and as we sat there, chatting, she told me about a new resident, a woman of sixty-five who had three university degrees. According to Stella, she was having a terrible time adjusting to the nursing home.

"Would she give me an interview?" I asked.

"I don't know," Stella replied. Then, a wry, defiant grin curving her lips, she added, "But I can ask her."

The bus pulled up outside. "I'll be back," I promised.

*

After the second visit to Birchwood, my husband was not in favour of a third. I'd come home even more upset than the night I talked to Wendy and Shannon, and in the intervening days I'd indulged in a great deal of internalizing. Other interviews had shaken me, but the Birchwood trio had been particularly dismaying, and the unhappiness of those women — the *loneliness* in their eyes — was preying on my mind. At night, my sleep was filled with grey, ghostly buildings threatening me. I *had* to return, as I wanted a representative study, and an older woman's life in a nursing home was probably more typical than the lives of the women I had already seen.

Finally, Bill agreed, and I had Stella take me to the lounge, where Ruby was resting. Stella introduced us, and immediately I was aware of the sense of inner misery the gentle, elegant woman projected.

Speaking rapidly — as if fearing I'd disappear before I'd heard her entire story — she told me of her education (nursing school, a B.A., B.Ed., M.A., and a good start on a Ph.D.), her teaching career in high schools and in two universities of high repute, her two children, and her broken marriage.

In 1980, at the age of sixty-four, Ruby had a stroke, which paralyzed her left side, although her speech was unharmed. When it happened, she was living in Montreal, but no nursing home there would take her for more than six weeks. "Then my son found this place," she sighed, shaking her head. "He thinks because you look at it, and everything and everybody *seems* so nice, that it's marvellous. My son and his wife wouldn't listen to me; not to one word I said."

The tears slithered down Ruby's finely lined cheeks. "I'll listen," I said quietly.

Since coming to Birchwood, she'd been in seven rooms, and some of the room-mates she'd had were trials to the soul for such a fastidious woman. "One was ninety-two, and she tore up rolls of toilet paper all day, spitting into it. Another kept wanting me to do things for her; things I'm too disabled to do. She couldn't understand what I was saying to her."

Eventually, Ruby was moved to a room she liked, where she had plenty of air, and two alert, personable room-mates. However, then the staff informed her she was changing rooms yet again. "They brought in a couple with lots of money," Ruby explained, "and they gave that room to them. Then they put me in the crummiest room, where there really isn't enough space for one person, and where I'm stuck in the corner, unable to see out. Then they brought in this woman...." She hesitated, as if afraid to complain too loudly about the new companion. Fortunately, Stella had already described her, and since I was staying for dinner, I would be able to judge for myself.

Ruby had raised the subject of money, so I felt confident in steering her back to it. "My children aren't paying for me," she answered, "and neither is the government. I have three pensions, and they *just* pay my way; on top of that, I haven't had a cent. There've been times I haven't been able to afford a postage stamp."

"Couldn't your children *help*?" I asked. The violent shake of her head and the closed expression in her eyes warned me I shouldn't pry into her relations with her family.

"There's no one," she added stiffly.

"Then let's look at your disability," I continued. "The rehab says you're one of the few who can recover from that type of stroke. How are you doing?"

There was a long pause as she regained control, wiping away the tears. In a shaky voice, she began, "Before I got put in that room, I was starting to dress myself. I could get on and off the toilet alone. But now I've slipped right back. The rehab has said I need a lower bed, so they can teach me to transfer independently, but I can't get one. I'm so fed up, I wish I could die."

"Do you have any privacy here," I prompted.

Alarmingly, Ruby began to sob. "When they're bathing you, they strip you down naked. I insisted I have a screen, but there aren't any. For a person with her mind, with all her mental faculties, this is very degrading. I have *no* dignity left."

What could I say? I could well imagine the embarrassment and spirit-destroying shame that modest, private woman must experience every morning. How could the nurses (very few of them are registered; most are personal-care workers with no formal training) remain aloof to such obvious suffering? I put away my questions: I'd upset her enough. Thanking her for the interview, I repeated the pledge I'd given the others.

A wild, tormented expression in her eyes, she grabbed my hand. "You *do* believe me, don't you?" I nodded; I believed her, all right.

All the time we'd been talking, we'd been continually interrupted by a bent, ancient man. He'd said nothing, but piece by piece, he'd upended most of the light furniture in the lounge. Now Ruby gestured to him. "He's the one who smashed the young people's lamp," she sighed. "He used to be a pharmacist. Now look at him."

Downstairs, Stella was waiting for me. She'd explained that she was on a special diet, because, due to the loss of body fluid from her open sores, she needed foods extra rich in protein. Also, because of a deformity in her esophagus, everything she ate had to be puréed. Otherwise, the food might stick in her throat, and she could choke.

Therefore, I was surprised when she held out a plate full of greyish rubbery goo on burned toast, announcing, "This was lunch. I just wanted you to see it." The goo was creamed ham, but very short on the high-protein ham, and the toast certainly wasn't puréed.

"What about your diet?" I asked.

Grimacing, she replied, "I seldom get it."

As Stella threw out the lunch remains, I was regretting my promise to stay for supper. But I kept my word, and as it was nearly dinner time, allowed Stella to lead the way to the dining-room. We found a table with little difficulty, and I was amused to notice how the kitchen staff were eager to impress a visitor. While exchanging pleasantries with them, I kept my eye on other tables, where the diners were served in silence, and where requests for seconds were filled grudgingly.

When dinner arrived, my stomach heaved at the sight: grey, overcooked meat loaf that looked as dry as cardboard, greyer potatoes that resisted my fork, sloppy, watery beans with most of the green boiled out, and anemic jello. I was going to be hungry when I got home!

But Stella's plate was the real shocker. *Nothing* was puréed. That meat loaf proved as tough as it appeared; the potatoes as hard. "I can't eat this," she whispered. I saw

the flare of anger, but her voice, calling to a waitress, was steady. "Please bring me a peanut-butter sandwich and a milk shake," she said coolly. She caught my eye, and shrugged: "It's protein," she said.

I had to admit this was true, but when the sandwich came the bread was dry and stale. The milk shake, which looked revolting, couldn't have exceeded four ounces. I remembered that Stella used the wheelchair because she did not have the energy to walk, and I thought, I don't see how this is going to give her much get up and go!

When she had forced down half the sandwich, and I had conquered the rocky potatoes, she suddenly pointed with her deformed thumb: "Look! There's Ruby's room-mate."

There, not six feet away, sat an enormous woman in her eighties, who was done up like a little girl. Her white hair was curled in ringlets, her face painted to resemble a china doll. Her dress was frilly and filthy, and her little blue eyes stared vacantly.

As I watched, she reached for the bread on the table, and, eyes darting to look for the attendants, she proceeded to stuff it down the waistband of her grey flannelette drawers. "Now I've seen everything," I remarked to Stella.

"She's always like that," she replied, disgusted. "Always dirty, always stealing food. She's diabetic, but they can't keep her on her diet."

"You mean, they don't bother to watch her," I grumbled.

I remembered Ruby's complaint about "a couple with lots of money", and I asked Stella to point them out, too. "Oh, they're not here. They eat in their room, a lot better than we do. There's a whole floor of them up there. "They have it okay. Birchwood has a van, which is supposed to take us for outings. But only the able-bodied and the wealthy get to go."

*

With four interviews on tape, I wandered around the main floor. I discovered a cigarette dispenser, which required

fine finger dexterity to operate, and which was too high for anyone with short arms. An individual with only partial sight would never have been able to make a selection because the symbols were so faded. Even the candy machine was difficult to use; it also required considerable motor function. And although it was too dark for me to see the walkways out back, I was assured they were too narrow for my chair.

Still, one thing bothered me more than anything else.... That afternoon, on my way in, I had navigated past three old women sitting in chairs in the gloomy hall. All had appeared senile, and they were tied into their chairs with ropes.

It was a gorgeous day, with just enough cloud and breeze to prevent sunburn, and I had thought, even if these women don't know where they are, wouldn't they be better off outside, in the sun and wind, than sitting, trussed up like Thanksgiving turkeys, in a half-lit, smelly corridor? It would have taken a staff member all of ten minutes to move three women; why hadn't anyone the compassion to do so?

I didn't leave the home that night until ten, and when I rolled down the hallway, I was aghast to discover that they were still there, exactly as they had been nine hours earlier. One sat, curled into a fetal ball, thumb in her mouth. Another was asleep, restrained from falling by her ropes. The third stared at me blankly. As I began to choke on the rising lump in my throat, I heard Ruby's voice in my mind: "This is a sad place; a very sad place."

I'd had all I could take, and I charged past the desk nurse without even saying goodnight. My husband found me in the parking lot, battling the terrible storm of emotion that three visits to the institution had whipped up inside me. Not since rehab days had I felt so helpless, or so angry!

*

Three weeks later, I arranged to interview an old friend from rehab days, only to discover that she, too, lived in an

institution. It had taken all that time to pull myself together following the Birchwood incidents, and I admit I didn't want to go. But I was anxious to see Elsie again, so I pushed my misgivings aside.

Elsie was living in Raintree Estates, a huge, government-owned complex in the downtown area of the city. From the outside, it looked even more like a hotel than had Birchwood, and I could see it was close to the shops and to the bus line. Still, after Birchwood, I cautioned myself against too much optimism.

I was early for the appointment, and the Access-A-Bus driver suggested, "Why don't you have lunch in the coffee shop?" Coffee shop? I was surprised; there had been no such convenience at Birchwood. When I rolled in the door, I'm sure that anyone watching must have thought me a trifle strange; for several minutes, I sat there and stared, unable to believe my eyes.

The place was *beautiful*! I was in the entrance of a self-contained shopping centre, with a beauty parlour, auditorium, and grocery store on one side, and a drugstore, barber-shop and coffee shop on the other. Everything was of modern design, with live plants set in tubs. The Muzak wafting from the loudspeakers was punctuated with announcements of activities. I began to wonder if I was in the right place.

I had a quick bite in the cafeteria, where young nurses, many of them with R.N. stripes on their caps, were eating; then, recalling Elsie's instructions, I found my way upstairs.

When the elevator doors opened, I took a suspicious breath — any stale urine smell? Not at all, just fresh pine and mild disinfectants. Wheeling down the hall, I decided the place resembled an apartment building, and when I reached Elsie's room, it was difficult to contain my relief. It looked like any two-person bedroom in a private home.

Large windows covered one wall, and every effort had been taken to make the place bright and homey. The beds weren't hospital issue, but convertibles — beds by night, sofas by day — and they were piled high with decorative pillows

bearing the distinctive signs of Elsie's beautiful needlework.

I hadn't seen Elsie since rehab, but she hadn't changed. She was still the kind, gentle person who'd been so understanding of a frightened teenager. And she still had the enviable ability to make me forget her severe hand deformities and leg amputations within a moment of the first hello. The interview went quickly and comfortably, so I went on to tell her about the Birchwood visits, adding, "Things seem very different here."

Elsie nodded, conceding the universal nursing home problems of overcrowding and understaffing, of noisy halls and lack of things to do. But she concluded, "Still, I like it here. It's not bad at all." I believed her.

We decided to go downstairs for tea and I thought of the women at Birchwood, brewing their own, with nowhere to entertain company, and with nurses constantly bursting in on private conversations. Conditions at Raintree might not be perfect, but they were infinitely more tolerable. I doubt if institutional life is ever truly pleasant for the resident, but at least Elsie wasn't saying, "This is a sad place."

On the way back to the coffee shop, Elsie took me on a brief tour. She led me through a wide, glassed-in breezeway, which was tastefully furnished in white wicker. Through the window she pointed out a quadrangle of immaculate lawns, with flower-beds blazing with colour. There was even an aviary, and we stopped to listen to the cheerful songs of exotic birds. The comparison with Birchwoods was staggering. And for the sake of a dear old friend, I was delighted. On a purely selfish note, I knew I would have no nightmares that night.

I didn't run into the nursing home situation again until the last week of interviewing, when I spoke to Sonja. At the time, she was living in one of the oldest facilities. I didn't see that one myself. Instead, I asked Sonja to come to my home. She described for me the conditions she had encountered: "I live in two miserable rooms in the basement, and there's no one down there but me. When it rains, the water trickles down,

and I get it. Some of the people are nice, but I'm only thirty-five, and the next youngest is over seventy. I can hear some of them in the night, crying over nothing."

That sounded pretty dismal, but Sonja had another complaint that bothered her much more. "Most of my friends are disabled, and if they want to visit me, they can't. There are steps outside, and the bathroom doors are too narrow." The idea of an inaccessible nursing home was incomprehensible. It occurred to me that those old people must never get out.

Happily, that home is closed now. I haven't seen Sonja since she moved out, but I've heard she's far happier, living in a home where there are other young people around.

In 1982 there was also good news from the women I met at Birchwood. Wendy and her fiancé are married, living in an apartment, with help from the various community service groups. And when Nova Scotia's first group home for the physically disabled opened— a kind of half-way house where residents learn to do everything they possibly can for themselves before moving into their own apartments (again, supported by the V.O.N., homemakers, and even Meals on Wheels)— Stella and Shannon were among its first occupants.

Unfortunately, Ruby remains at Birchwood. She has slipped, physically and emotionally, even further, and last time I had word of her, she was bedridden, able to do almost nothing for herself.

Now the big push towards independent living is on! For one thing, it's becoming far too expensive for the government to keep individuals who don't require full-time nursing in institutions. For another, most people are happier in their own places; coming and going as one pleases does wonders for one's pride and self-image. And as psychologists have shown, happy people tend to be healthier.

In the future I believe we'll see fewer and fewer nursing homes, until institutions will be maintained only for the very senile and the very sick. I think we'll see a trend toward the establishment of superior community service care; in England and in Connecticut, this move is already well under-way.

For the moment, in Nova Scotia, a major government Task Group has been formed for the purpose of studying all aspects of institutions serving the aged, disabled, and mentally handicapped. Interested groups and organizations, such as disabled consumer groups, have been invited to participate by submitting written comments expressing their views.

This sounds like it may be a step in the right direction; I, for one, eagerly await the results. As a friend of mine is fond of saying, "We've all got to be interested in nursing homes, not only the disabled. We *all* get old!"

Sticks and Stones

"Sticks and stones may break my bones,
but names will never hurt me."

Hogwash! Give me the physical blow, any time. That kind of pain is, to me, infinitely preferable to the subtler, lasting hurt that comes with the cruel, thoughtless words. Granted, no one enjoys overhearing uncomplimentary remarks like, "She's too fat", or "She's ugly." However, disabled people find themselves reeling from painful slurs far more often than the able-bodied (racial minorities excepted).

I asked the women I interviewed about the labels that trouble them most. "I don't like 'patient'," said Greta. "That makes me think of someone who's sick, like in a hospital. And the majority of disabled people are not sick."

What else?

"Case," Greta replied promptly. "Let's see...there's a case of pop, and a case of measles, and lawyers take cases. But I don't like being one."

I feel I understand that particular annoyance as well as anyone. In almost twenty years, all manner of weird medical problems have happened to me; the hospital I frequent has an enormous file on them. Doctors love me because I'm such a fascinating "case", and until I stick up for myself, informing them I'm a human being who won't tolerate being treated

otherwise, I'm viewed as nothing more than the sum total of the ills in my file.

Greta and I also became furious when we hear that so-and-so is "suffering" from a disability. True, there is usually some physical pain involved, at least at times, but that's the *result* of the impairment, and it's seldom constant.

"Maybe we're suffering from the attitudes of others," Greta wryly commented.

Right. When I hear, "She's suffering from MS — or whatever," I smell pity, and few things make me angrier.

Then there's "victim". Greta has been known as a "victim" of polio. She had difficulty expressing her feelings about that one, and blurted, "It makes me feel so...so *victimized*!" I think she meant "dehumanized". She doesn't consider herself a victim, and she can't understand why others insist she is.

In an attempt to get beyond the labels, I asked some of my respondents what they would prefer. Marsha: "I think people should be who they are, by *names*. It isn't right we have to brand disabled children 'crippled children'; it isn't right that I should have to be a 'partial quad', and you should have to be a 'para'."

But society loves labels; they're not going to disappear just because we wish they would. I rephrased my question: "If you have to be called something other than your name, what would it be?"

Surprisingly, I ran into a bit of disagreement. A few insisted on "handicapped", but they were in the minority, drowned out by those who preferred "disabled".

Greta summed up the most prevalent attitude: "I like the definitions in the United Nations book, *Obstacles*. First, there's "impairment", which is the actual physical disability. I had polio, and the impairment is the damage to nerves in my spinal column. "Disability" is the effect of the impairment; for me, I can't use certain muscles. A "handicapped" is an obstacle that prevents you from doing what you want to do. When I come to a flight of stairs, *they* are the handicap."

Interesting. I've hated "handicapped" for years, without really knowing why. Personally, I'm not crazy about "disabled", either, and if I *have* to be categorized, I prefer "paraplegic". At least it's a straight forward medical term that simply means I'm paralyzed in my lower body and legs. Since the forty-five women interviewed have eighteen different "impairments", and since forty-two of them choose "disabled" over "handicapped", I've usually used "disabled" in this book. That doesn't say I have to like it, and on the whole, I agree with Marsha. People should be known by their names.

Sometimes annoying labels arise from within the disabled community. A perfect example can be found in Yvonne Duffy's otherwise excellent book, *All Things Are Possible* (see chapter on sexuality).

Ms. Duffy has somehow hit on the phrase "Differently Abled" (capitals and all), and she uses it ad nauseam. To me the term seems a euphemism for children, and as usual, I resent the stress on "different". Able-bodied readers may protest that all this fussing is mere nit-picking; and in a sense, they will be right. To us labels are such a real issue because of the way they *set us apart*, not because of the actual words. With one exception....

That exception is the worst, the most painful of all: "cripple". Derived from an Old English word, *crypel* — meaning creeper — cripple fills my mind with visions of the days when disabled people formed the majority of the begger population. In times before wheelchairs, proper crutches, and white canes, the disabled were reduced to begging, creeping around city gates, bowls in hands, pleading for hand-outs.

Those pictures have absolutely nothing to do with my reasonably healthy image of myself, and when I asked my respondents what they thought of the word, their answers came quickly, often violently.

"Oh, I despise that word," cried Isobel. "I always have. I think it should be taken out of the dictionary."

While none of us cares for the word, Alsion finds it coming at her in a particularly painful manner. "I get it from my mother. She hasn't been around disabled people before me, and she doesn't know how to talk about it."

Lynn ventured the opinion that hearing "that word" is always worse when it happens in front of one's friends. I concur. When I'm out shopping with an able-bodied friend, and we're chattering away, having a good time, we both forget all about my disability. Then a clerk refers to me as crippled, and instantly, the damned disability comes between my friend and me. It makes us conscious that I am different, that I am seen as abnormal.

Cindy explained why she has to speak out against that one word: "I realize as soon as someone says it to me that I have nothing in common with that person; that I don't want to spend another second in his or her company. 'Crippled' is everything that's in an individual, and it's not everything in me that is affected by my disability." Others say they'll take it once, but will tell the offender how they feel, to give them the benefit of the doubt, as it were. *However*, should the same person use it a second time....

A few easy-going souls manage to brush "cripple" off with all the other things, dismissing it as plain old ignorance. But all agree they'd be happier if they *never* had to listen to it again. Despite our protests, "cripple" — as well as other hurtful terms — remains in wide use. Greta, who's a strong, independent paraplegic, blames the media. "When you hear reports of something going wrong with ships at sea, they're always 'crippled ships'."

And respected NBC anchorman, David Brinkley, narrating a documentary on Franklin Delano Roosevelt, boldly announced, "FDR was a cripple." A few months later, during a CTV report on the 1960s, Harvey Kirck's script referred to children born with thalidomide disabilities as "these flawed children".

When the labels originate from such sources, is it any surprise that the public finds them acceptable for everyday usage?

Negative labels such as cripple or victim are upsetting, frustrating, and sometimes painful, but there is another class, the positive labels, which can prove much more unpleasant and far more difficult to escape. These are the verbal pats on the head, which are calculated to make us feel terrific, and which have precisely the opposite effect!

"You're so courageous." Wouldn't I love to have a dime for each time I've heard that! Also, "Oh, my dear, you're such an inspiration." From the very beginning, I hated those comments. I found them embarrassing, patronizing, and sometimes plain old sickening. I didn't — and don't — like being praised for doing what's necessary to survive.

Of the forty-five women interviewed, only three actually liked that sort of thing; the rest shuddered and pulled faces at the very mention of words such as "courageous", "inspiring", "brave".

Robert A. Heinlein, the distinguished science-fiction author, contends that true bravery involves the ability to make a choice. For example, a soldier who risks a dangerous mission when he could back out is a courageous man. But the man disabled by war *can't* back out; he has no choice but to learn to manage. Friends have argued that point with me. They say, "You had a choice. You could swim or sink, live or die."

Really? What kind of a choice is that? I was seventeen, and I wanted to live; where was the choice? The alternative meant years alone, the contempt of my peers, the knowledge of being a burden on my family, and eventual death, possibly by suicide. No, there was no choice; I survived because I had to. Because I was too stubborn and pigheaded to give up.

When people tell us how brave we are, what they're really seeing and reacting to is a mixture of stubbornness, perseverance, and *pride*. It is pride that prohibits us from displaying pain in public, and this is one of the forces driving us to live as normal lives as possible.

But how can we live normally if people insist on placing us on a pedestal? We can't; in the midst of constant praise

we can't get on with the business at hand, which is to live one day at a time, making the best of it.

I asked Chris and Cindy, "How do you feel when you're told how 'courageous' you are?"

Their expressions told me they knew all about this battle. "I don't know how to cope with it at all," sighed Chris. "First of all, being disabled makes people look at you as abnormal. To try to prove you are a person inside — that everything's the same as theirs — is very difficult. You don't want to be on a pedestal."

Cindy agreed: "This fall, Chris and I are going to university, and it's been, 'Oh, isn't that lovely! My God, that's wonderful. You girls have a lot of courage! Our younger sister, who isn't disabled, is also going to college for the first time, but she doesn't get that. It sets Chris and I apart, and we resent it!"

In that sense, the positive labels are really no different from the negative. These "nice" things people say about us constitute another means of making us feel different, and like the negative, they rob us of our human dignity. It's much easier to complain about the negative things; when a sweet old lady gushes over me, telling me how much she admires me, I find it very difficult to set her straight without hurting her. She believes she's complimenting me; how do I ask her to spare me without going through all the things I've done wrong in my life?

Those comments are frequently delivered with condescension. I can cope with my disability, but it puzzles and upsets me when I realize the nondisabled have a much harder time, that they find it almost impossible to treat me as a person. Sometimes I get so angry I want to scream. And yet, some people genuinely mean what they say; they're not just trying to be nice to a poor unfortunate. *Then* what?

I feel that if someone honestly finds inspiration in the way I live my life, that's wonderful. I would hope he or she would then go on to use it in his or her own life. But I wish no one would *tell* me about it! And if they absolutely feel they

must say something, then I wish they'd wait until I'm alone, that they wouldn't do it in front of others, and especially not in front of my friends.

Lynn provided clear analysis as to why admiration is a problem when friends are present: "My attendant is a dear friend, and we've had real troubles because people are always coming up to her, saying, "What an inspiration you must get from Lynn; what a wonderful thing it must be to live with her." But she knows I'm no angel; I constantly take my problems out on her, and I'm not always so terrific to be around. It's very, very hard on *her* ego when she's constantly put in the position of having to see me on a pedestal. It takes a very strong, well-centred person to handle it."

This partially explains why many disabled persons have difficulties relating to other members of their families. When a disabled child is a monumental brat at home, it's confusing and infuriating for her able-bodied siblings when the little hellion gets all the attention and praise. This can give the able-bodied children a twisted view of all disabled individuals and it's one reason why people who live with the disabled on a daily basis can be the least understanding of all.

When people shower us with praise, it's almost impossible to know how to respond. Equally problematic is: "Talking to you has made me realize just how lucky I am." Oh...oh. That's one's tough because the feeling behind it is totally normal; it's the old "no matter how bad things are, there's always someone worse off" feeling.

Question: how do these people know that their life is superior to that of the disabled individual? And in what way?

I'm sure we've all felt, there but for the grace of God go I. The problem doesn't lie in experiencing the sensation, but (again) in *telling* about it. In rehab, when I watched the young quads struggling to pick up paper cups, I thought, that's where I've been; I've come a long way.

I couldn't help being grateful for the use of my hands, but I certainly didn't go up to one of those fellows and tell

him, "You've shown me where I was. I won't complain so much now." That would have been cruel and thoughtless. So why do able-bodied people do it so frequently? I would suspect it's lack of tact, rather than the desire to hurt us and to make us dissatisfied with our lives.

We all know the feeling is natural; it's a fact of life. However, as Monica said, "I wish they wouldn't act on the fact."

Along with the negative and positive labels, we also get what Sandra termed "the stupid stuff". People who aren't comfortable around disabled individuals, but who are trying to play it cool, will frequently ask silly questions, such as, "How many miles do you get to the gallon?", "Get any tickets lately?", or "Do you have a licence to drive that thing?". The list is endless. These aren't nearly as painful as "crippled", nor as embarrassing as "courageous"; nevertheless, they are exceedingly wearing.

Sandra explained how such comments make her feel: "I always think, why don't you say something like, 'Nice day?' Why do they always have to make some reference to my wheelchair?"

And there are other ways of making the disabled feel like a separate breed. In 1981, the separation between "us" and "them" was reinforced in the most unlikely of circumstances; at the annual dinner of one of the major support groups for the disabled. That night, the chairman of the organization, himself a quadriplegic, prefaced his welcoming remarks with, "Good evening, honoured guests, fellow paras, and quads." *Immediately* we were set apart from the able-bodied people in the room. At our own dinner!

Stunned, we couldn't believe our ears. One woman, eyes glistening, moaned, "Not here!" An angry young man snapped, "I've never been so insulted in my life. I was furious and hurt, biting my lip, not trusting myself to speak.

Why — in God's name *why* — couldn't the chairman have referred to the disabled segment of the audience as "old friends"? Even there, at *our* reunion dinner, we weren't allowed

to forget that we are different! (Although I must admit, I don't know how much longer it will be *our* dinner; each year the proportion of able-bodied dignitaries increases.)

Coming one by one, the labels aren't so bad, but over a period of years, the effect is cumulative. It's *all* so damned dehumanizing. I've often said of myself, "My body may be disabled, but *I* am *not!* Whatever it is that makes me a human being, special to myself, there is nothing disabled or handicapped about it!"

Patty quietly added, "I'm a human being who just happens to be on wheels."

<p style="text-align:center">*</p>

From the onset of any disability, a person has to learn to deal with the curiosity of the able-bodied. Wheelchairs, crutches, white canes, or hearing aids: they all attract attention. I wouldn't begin to try and estimate how many times I've been asked, "How did it happen?". It crops up in conversation every time I meet someone new. Almost as frequently it comes from total strangers who don't even bother to introduce themselves.

At first, I deeply resented the intrusion of privacy. I was still grieving, and I didn't want to talk about it. Later, when asked, "Were you in an accident?", I sometimes found myself saying yes, to avoid complicated explanations so that I could get on with what I was doing. Finally, I became bored with the whole thing, and my answers, while usually polite, sounded stiff and stilted to my ears. I was tired of the unending, "Will you get better?", and "You'll *never* walk again?"

Then I stopped and thought about it, and I realized that if we don't respond to the interest of the able-bodied, no one will. Who else can try to convince them we're really no different? And if we don't answer their questions, do we still have the right to complain that they don't understand us? I think not.

Marsha believes straight answers are vitally important: "I have a theory that something disabled people do not want

to do...is express themselves. So when I'm asked questions, I answer them truthfully and try to help people understand what I'm about, and how I feel about what I'm about, rather than just rolling off saying, 'It's none of your business.' I think that attitude is wrong. Disabled people make a very big secret of who they are, and they're paying hell for it now."

Several years ago, Marsha organized and conducted a workshop for the board members of one of the chief support groups for the disabled. She quickly discovered that those people, who should have known how things were, understood annoyances like accessibility, but had no idea of the deeper, more painful problems. "They thought," Marsha reported, "everything was well in the world of the not-so-well, that we had no major problems. They were very alarmed at the people who are out of reach of the workshops, who are very, very much alone, contemplating suicide."

"Whose fault do you think that was?" I asked.

"I lay the blame for this entirely on the professional people who know the end result of rehab, on the support organizations, on the disabled themselves, and on all the do-gooders, who are only trying to do their best, only to realize they don't have a clue as to what they're dealing with."

If we're ever going to persuade people to treat us as human beings, rather than freaks or second-class citizens, then *we're* going to have to get out there and teach them about ourselves one by one, if necessary. And that means responding truthfully to questions, even when we'd rather talk about something else.

I remember, with considerable pleasure, one occasion when it appeared I was able to change someone's opinion re the disabled. I had an emergency doctor's appointment. My husband couldn't come home to pick me up, and the Access-A-Bus was booked to overflowing. I called a taxi.

Harry was about 45, short and fat, bald and pasty-faced. As I rolled out the back door, he took one look at me, and I could read the suspicion and aversion in his red-rimmed eyes.

I struggled against the blustery wind, attempting to close the door, for maybe five minutes, but Harry just stood stiffly by his taxi, watching. By the time I got down the ramp, I was beginning to steam.

"You expect me to take you by yourself?" He was amazed at my audacity. "Well, I dunno. You people ought to have someone with you to take care of you."

"*You people*?" His tone made it sound like, "You Martians", or "You chimpanzees". It wasn't difficult to guess he'd had little or no contact with the disabled. I didn't wait for the questions to start. All the way to town — a good twenty minutes — I peppered him with information. For half the drive, his reactions upset me, although I wasn't about to show it. I was *married*? My husband *wasn't* in a wheelchair, too? I was *working*?

However, as his stereotyped views faded, he began to relax. His questions became more intelligent, and while I could see he wasn't far from telling me how "inspiring" I was, for once I didn't care. I had to break down his antagonism in any way I could. When we reached our destination, he stood clear of the car and allowed me to transfer by myself; earlier he'd been afraid I'd ask him to lift me. And instead of grabbing the chair to push me up the ramp, he grinned, "I'll give you a shove — *if* you want me to." Now that was more like it!

We said goodbye at the doctor's doorway, and as he returned my change, he smiled sheepishly, his head down. "I guess you are just like anyone," he said. Victories like Harry make the frustration and pain of involved explanations worthwhile.

However some people go too far with their questions. When I was in hospital with meningitis, I was terribly self-conscious and embarrassed about the indwelling catheter that drained my paralyzed bladder. I hated the thing with a passion. I wasn't happy when, the first day I was allowed visitors, one of my school friends asked, "How to you go to the bathroom?"

In nineteen years I've had that query thousands of times, and I will gladly sit down and explain the whole problem to a close friend or to someone who needs to know. For strangers, my 1983 reply is the same as the 1963 version: "With difficulty." Usually, that precludes further probing.

It sometimes seems as if people feel the rules of polite society shouldn't apply to us. And we don't react too well to the undisguised, gaping stare either. Said Kim, "I stare right back. I let them see how they like it."

Well, as long as questions are honest, and the inquisitor demonstrates some regard for our feelings, the majority of us are willing to provide a little education. When curiosity isn't prurient or sadistic, we believe straight answers are vital.

It's the exceptionally personal questions that daunt us. Kim, whose deformities won't even permit her to sit upright, said, "Someone actually came up to me, right out on the street, and asked, 'Have you ever had sex?' That was too much!"

Indeed. I can't imagine where people get the idea that because we look a little different they have the right to ask all manner of intimate questions, whenever and wherever they choose. How would most able-bodied women react if they were approached in public and asked, "Can you have sex?" (If anyone asked me that, I'd be inclined to reply, "When?" or "Right now?")

On occasion, when I feel a friend wants to know something, but is having difficulty asking, I will try to find out what's bothering her. I don't like having barriers of speculation between us; usually the answer isn't half as dreadful as she had thought. I prefer having everything out in the open, much as I appreciate the concern for my sensibilities that inhibits the queries.

That's a personal decision, however, and not all share my preferences. Greta said: "I have friends I've known for years and years, and they've never asked me personal questions. I know they must have thought them, but they've never asked."

And then there is that minority of disabled individuals who want to talk about little *other* than their disability. For some people, it's their chief claim to fame, and anyone who will listen hears all about it. However, those few are usually pretty easy to spot. The majority of us will answer questions if we have to, but we really would rather discuss any of the world's more interesting subjects.

Greta told me a fascinating story, which vividly revealed a difference between the lives of disabled people and those of the able-bodied. Since it deals with curiosity — or the lack of it — I thought I should include it here.

"It was the one and only time I was on an intercity bus. They lifted me on at the terminal, then they went around the city, picking people up. This lady got on, sat next to me, and we chatted all the way to Lunenburg, where she got off. She'd even given me her address. And she never knew I was disabled; I didn't tell her, and she couldn't know by looking at me. That was the day I found out what it was like *not* to be disabled. If she had known, she would have started asking me all those questions, but as it was, it was so different, it was just outstanding."

*

"What do you think we should do about children's questions?" I asked each respondent.

To my intense relief, every women agreed — even if she didn't like the idea — that we absolutely *must* satisfy the inquiring minds of the very young. Many, who view the parents as being out of reach, see all our hopes for future understanding and acceptance in the candid eyes of the children. Therefore, we must be direct and honest with them.

"Kids are fascinating," Marsha stated grinning. "They know when you're holding back, or whether you're being honest. They can be very cruel, but I like children to ask because I think I'm so much more aware of how fragile the human body really is. I tend always to slant my replies toward children looking out for themselves. I want them to be aware

that this isn't something that's very isolated; that it can happen to them."

Marsha's quite right. Levelling with children means more than insuring our own future acceptance; it means warning them of potential dangers. Disability can happen so easily, to anyone, and if children recognize the consequences, perhaps they'll be more likely to guard against foolish risk taking. There are too many disabled people now, and most injuries arising from trauma are preventable.

Dr. Brandt was concerned about how children's attitudes toward the disabled might be affected by the attitudes of their parents: "Kids come up to me, and a wheelchair can be very exciting. They want to see how it works, or it's 'Look at that lady'. And in a very high-pitched voice, Mama shushes them. It's as if the children are being given a negative association; that they're being told there's something bad about the disabled. That upsets me because they're being taught an avoidance."

I share that concern. Many times I've just launched into a careful explanation on a child's level when along comes the parent, who hauls little Johnny out from under my nose. After a few such wrangles, in which I tried to persuade the parent it was okay, the child became confused. I learned it was less disruptive to keep quiet and allow my very willing student to be snitched.

And while I didn't talk to any disabled people who hate the eager questions of children, many do resent them. Dr. Brandt added, "Not everybody feels the way you and I do about kids. Some are very annoyed that their parents will let them ask. This is what we have to keep in mind: the disabled are just like everyone else, and they come in all kinds and variations."

I think the best advice for a parent, whose child is hell bent on pursuing people in wheelchairs, on crutches, or with white canes, would be to take their cue from the disabled individual. If she doesn't want to talk to your child, you'll

know it; her expression will tip you off. But I would like to say to parents, if your child is having a great conversation with a disabled person, don't interfere, please. When it could happen to your child any day of his or her life, do you really want to be responsible for teaching an avoidance?

While I was interviewing in the nursing home, Shannon said, "They should have someone in a wheelchair go around into the schools and talk about disability." This excellent idea is already being implemented in some communities. Various disabled consumer groups are sending representatives into the elementary schools, where they present slides and a lecture covering the different disabilities. After a formal presentation, they interact with the children, answering as many questions as possible.

So far, the plan has met with considerable success. Following a long, productive morning of relating to third and fourth graders, Monica commented, "Now maybe they'll go home and educate their parents."

Obstacle Course

Anyone who lives with a disability will agree that our lives are ones of constant planning and organization. How to get from point *A* to point *B* without encountering numerous pitfalls is a concern that takes time, effort, and frequently, guile. How many steps? Is there a ramp? Which door should I use? Are the washrooms accessible for a wheelchair? Unless one is prepared to deal with unpleasant surprises, these are questions that must be answered before leaving home.

To my mind, accessibility is not one of the horribly painful problems faced by the disabled. We all know we're going to have difficulty getting around, so with a resigned sigh, and a few well-chosen curses, we accept the fact. Reluctantly. The problem is like a persistent toothache, that never really goes away. And when one is unable to chart one's own course without encountering numerous obstacles, it's easy to become discouraged.

"I never realized what terrible condition the city streets were in," puffed my mother as she tried to push my chair through a pot-hole. Bouncing and jarring along in front of her, I wholeheartedly concurred. It was late March, 1964, my first afternoon out of rehab. I had a two-hour pass to visit the nuns at the convent where I'd taken sick, and I'd been looking forward to it all week. The last time I'd seen any of them, they'd been peering into the back of the ambulance that took me to hospital.

However, Mom and I had only gone half a block when I began wishing for the wide, polished halls of the rehab. It had snowed the night before, and the hastily plowed streets were bumpy with salt and sand. Underneath there was ice, but it was not thick enough to disguise the cracks in the road surface. We didn't have far to go, but we spent half an hour grappling with that most annoying obstacle of all: curbs. In those days, street corners weren't ramped, and my mother, who was only just learning the ins and outs of handling a 56-pound wheelchair containing 115 pounds of daughter, had a ghastly time getting up and down those six-inch steps.

The nuns were waiting for us, standing like little black birds at the top of ten concrete stairs. Anxious to see the teachers who'd been kind to me, and new at this disability game, I hadn't ever considered the problem of getting into the convent. And it was too cold to sit outside to chat.

No one had told us that two people, one in front, and one behind, could whisk a chair up and down steps far more easily then four. Eager to help, the nuns grabbed back, front, and arms. "The arms come out!" I cried. Too late. I ended up with a nun on each corner, all trying to cope with chair, voluminous habits, and wind blowing veils in faces. I decided that I would not be coming back to the convent in a hurry.

The next time I ventured out of rehab, the snow had disappeared. Unfortunately, cracks and bumps in sidewalks and roads had not. A student nurse took me to a movie that afternoon, but we were stopped by steps inside the lobby. How were we going to get in? An adolescent usher took one look at us, his eyes popping and his jaw hanging open. Then he ran to get the manager, while I searched for something to crawl under. I was upset by the way the other customers were staring at me. That awful, sinking sensation of being on display, like an animal in a zoo, was my first exposure to the ignorance of some people. Finally the manager appeared, leading us out of the lobby, down a long hill, and into the theatre through the fire exit. My self-image was a tad tarnished, but at least I got to see the movie!

It wasn't until we were nearly back to rehab that we got ourselves into the real trouble of the afternoon. In front of the Children's Hospital, where kids in chairs had to pass every day, the sidewalk was the worst I'd seen. The nurse and I were exhausted from the length of our trip (about a mile, each way) and from the dozens of curbs we'd dealt with. And I wasn't looking where we were going. My front wheels tangled with a jagged crack, and I went flying, landing on my behind. I clutched for my skirt, frantically pulling it down (*why* did I have to pick that day to decide I wanted a change from slacks?). The student panicked, running to the nearby cab stand, howling for help.

A sweet taxi driver, trying valiantly not to laugh, picked me up and put me back in my chair, then we hurried to rehab, where the nurses checked me over for the bruises that could have kept me in bed a week or two. I'd learned many lessons that day, most of them painful. Never again would I allow *anyone* to push me unless I had one arm wound firmly around one of the chair's handles!

When Alison and I talked about those early trips out of rehab, I recalled an experience I'd had in a restaurant. I told her how the aisles between the tables had been too narrow; that they'd practically rearranged the furniture just to get me in; and how I'd hated the feeling of making an entrance. She well understood that affront to dignity.

"My boyfriend came to visit me," she said, "and he had to lift me up into the restaurant. To me, that was so degrading. I hadn't seen him since a month after my accident, and I thought I'd be walking the next time. Then he came down, and he had to deal with me, the wheelchair, *and* all those stairs. It wasn't a pleasant evening, let me tell you. When you have to be carried into a room full of people, you can almost hear their necks cracking: What was *that*?" After nineteen years, I still despise having to be carried. Whether people help pick the chair up, or whether my husband lugs me around like a sack of potatoes, I *hate* it!

If we don't want to be public spectacles, the obvious answer is to go places where there are no steps (we're back to organization and planning), but it's not always so simple. Private parties are nearly impossible for us as modern homes are miserably inaccessible. Just as there is no way to squeeze a wheelchair through the narrow doors of restaurant washrooms, the skinny bathrooms of today's bungalows can be hell for the paraplegic with a weak bladder.

It is getting easier now to go out on the town. Newer restaurants sometimes have ramps, the spaces between tables are wider, and the washrooms have one enlarged cubicle. The problem then becomes one of limited choice. If we don't stick to those few accessible places, we're going to get in trouble again, and it is really frustrating to have to plan one's entire social life around ramps and washroom doors.

With the proliferation of large malls, shopping is a great deal more convenient than it was when I left rehab. At that time, each store was a separate building, and each posed its own difficulties. On the other hand, inside a mall I can move around unhampered, until I want to try something on in a clothing store. Ninety per cent of them have such tiny changing rooms that I can just about get the foot rests of my chair in. Oh well, I'm finally getting used to being whisked off to managers' offices (where there's never a mirror). Or else I persuade the sales staff to let me take things home on approval (when the sign clearly states "No Approvals").

This is a minor hassle, and if it happened only once in ten shopping trips, I doubt that it would bother me. But the effect is cumulative, and years of not being free to try on clothes in peace do little for a person's temper.

However, the complaints about grocery-store check-outs are not minor. Georgia, disabled only a few years, cites them as her pet peeve: "I can't get through them. I put my groceries on the counter, then I have to whiz around to the other side."

"Hollering for someone to pass your things through to you," I added. I could tell that it was the same old problem for Georgia; she doesn't like calling attention to herself, either.

*

Any improvements that have been made in accessibility are largely due to change in the building code, which came into law in the mid-1970s. Unfortunately, the code is not sufficiently effective; it states that buildings must be accessible to the disabled, then provides too many exceptions, too many ways for the unconcerned builder to weasel out. Until the government establishes an airtight, thoroughly effective code and *insists* builders follow it to the letter, we're still going to find new places going up that aren't completely accessible. For example, those lovely shopping malls I just mentioned often have terrific electric doors outside, but inside the washroom doors are so heavy I can barely handle them. Once I even got stuck in a washroom at an ultramodern hospital. Also, why doesn't every church have a ramp?

One difficulty that should be solved in the near future is that of too-high public telephones. Oh, I can reach to dial (thanks only to long arms), but what good does that do me if I can't get the coin in?

Greta addressed this concern: "It's degrading when you have to ask someone to put the dime in for you. The slots are just that little bit high, and you get the coin up, almost in the slot, then you drop it on the floor, it rolls in a corner, and you can't find it. Great fun! Well, at least the telephone company is working on that one." The phone company is on the job; recently it marked special phones for the use of the hearing-impaired.

Most accessibility problems can be solved by asking the able-bodied for help. That isn't the point. The disabled are like everyone else; we want — *need* — to be able to run our own lives, to do as many things as we can by ourselves and for ourselves. Besides, once we ask, some people don't know how to restrain themselves, barging in and taking charge, never listening to what we actually want of them. As Greta explained, "The public is willing to do things for disabled people, but

they don't realize what it's like not to be able to do those things for oneself."

Some not only don't realize, they're not even willing to try to understand. At a party several years ago, I was discussing recent improvements around the city with one of the guests. Her husband chimed in, "Well, I think it's all becoming too damned accessible. Those ramps on corner curbs are bloody nuisances." He sounded like the kind of people who deliberately park their cars in spaces reserved for the disabled, despite the prominent signs.

As far as I'm concerned, ramped curbs are a godsend, a genuine boost toward independence for disabled persons. The walks that cost my mother and me so much in terms of energy, time, and frustration can now be accomplished easily, by me, *alone*. Buildings continue to pose problems, but at least I can get around the city if I need to, with only the occasional snarl up in traffic. This means so much to my image of myself as "normal".

Eventually, accessibility will not be the persistent headache it is today, but we can't leave all the planning and renovation to the able-bodied. Again, we're going to have to educate the public about our needs, and the more people who come to understand what it's like not to be physically independent, the better. That's where "Awareness Days" come in.

Periodically, a city sets aside a day when prominent people, who might have influence over such matters (politicians, media personnel, city planners), volunteer to spend an entire day in a wheelchair. They don't get a very realistic picture — too many others are eager to look after them, bring them things, push them around — but it's always fascinating to read their reactions in the next day's paper.

"Everything's too high!" "I couldn't get into the washroom!" "Somebody's car blocked the ramp!" "They had to carry me up and down steps!" My, but that sounds familiar. It doesn't take long for those people to become totally frustrated, and it is to be hoped they will always remember how they felt. And, that they will act upon their outrage.

However, Carol warned that "Awareness Days" are not enough. "Awareness has got to be more than some handicapped people presenting a nice little session so at the end of the day people can go home thinking, yeah, that's really true... and then forget about it. It's got to be more activist, more lobbying. Awareness is fine, but not if you don't do anything about it."

With problems as thorny and as constant as the obstacles we encounter at every turn, it's a wonder any of us manages to keep her sense of humour. And yet, I've found annoyance can be countered with a joke, just as irony often takes the edge off embarrassment.

Didi appears to agree. "It's slightly embarrassing to have to be carried *into* a tavern," she said gravely. Then, with a grin: "Most people have to be carried *out!*"

In one regard, disabled people are like anyone else; we are customers for services, consumers. The majority of us may not have much money, but what we have, we spend; we pass it on to people like the owner of Didi's bar. Doesn't that suggest that making a bar or store accessible might be profitable for the owner, too? Hmm....

*

Almost everyone knows the vexations of house or apartment hunting; one certainly doesn't have to be disabled to encounter those trials. But the usual problems are always magnified for individuals whose impairments demand they locate large, spacious rooms, bathrooms accessible to wheelchairs, kitchens with easy-to-reach plugs and appliances — all in buildings with ramps and convenient parking. And even when the perfect place is discovered, it frequently turns out to be too expensive for those on social assistance or other types of fixed income. Or it presents difficulties in travel arrangements to and from the job, shopping malls, and/or the doctor's office.

The combined problems of accessibility and affordability have hampered many of my respondents. "Recently", Didi said, "I looked for an apartment, and it was just incredibly frustrating. So many buildings weren't accessible, and those

that were were more expensive. In the past, I've had to spend more than I could actually afford. Right now, I'm living with my father, near the place I work, but there's quite a hill to manage, and I'm going to have to pay for transportation once it gets slippery out."

When I first left rehab, I didn't have to face such worries. I was lucky for my parents' new home had a downstairs bathroom, bedroom, and den. I immediately appropriated those rooms as my "apartment". The ramp built from the sidewalk to back door was ungainly, but it served its purpose; it gave me the freedom I craved.

It wasn't until I was married that I ran into housing problems. Our first apartment was in a modern high-rise, where the elevators were tiny and had doors which closed too quickly. I was always afraid of losing a few toes.

The bedroom wasn't bad, but there wasn't enough space for me to make or change the bed; we slept on a hide-a-bed in the living-room. I could manage in the kitchen if I really thought about every move, and the landlord had widened the bathroom door. Still, getting in and out was a major feat, requiring considerable time and effort. With so many drawbacks, we weren't happy there, and when our female Siamese went into heat, howling at the top of her lungs, we were told to get rid of the cat, or leave, ourselves. What a great way to break a lease!

The next apartment was terrific, with huge rooms that I could navigate in comfort. It had a large, old-fashioned bathroom, and while I couldn't turn around in the skinny kitchen, once I was in, I could reach all the lower cupboards and one level of the uppers.

The floors were the chief indoor nuisance: they sloped. Apparently, the building had resettled after the 1917 explosion in the Halifax harbour, with the result that one side was lower than the other. If I parked in the living-room or bedroom, and forgot to put on my brakes, I slowly rolled to the opposite side of the apartment. It was annoying, but when I realized

how much we were saving in rent, I decided I could live with it.

Not so easy to handle was the situation outside the main entrance; there were nine *curved* steps. Every time I wanted to go outside, I had to be taken. There was no way to get out on my own. Since I was usually with my husband, it didn't bother me too much (although there was the old hatred of being carried to contend with), but one day I had to go to a TV station for an interview, and Bill wasn't available to help.

Nervously, I called the cab company most often patronized by my disabled acquaintances. I asked them to send a driver familiar with wheelchairs, someone who could bounce a chair up and down steps. They sent a tiny little chap who didn't look as if he could manage a baby stroller.

Back to the phone. The second time, a big, husky chap arrived. I breathed a sigh of relief; the interview was to be broadcast live, and if I didn't hurry, I'd be late.

"Hey, missus," he wheezed, "I got a heart problem." In a panic, I phoned the Paralegic Association and they solved the problem. Along came another taxi — with two drivers! When I got to the station, the interviewer was on the front steps looking for me; I climbed out of the cab thirty seconds before I was due on the air.

After a couple of years, I was thoroughly fed up with those stairs, and Bill was tired of worrying about the risk of fire. We decided it was time to start looking for a house. Knowing we couldn't afford to buy in the city, I allowed myself to be coaxed into seeing a suburban bungalow. And the first one we investigated was perfect; it needed only a ramp. I couldn't believe it; the wide bathroom door was a particularly pleasant surprise. The builder had gotten rid of every tree on the lot, but the place was heaven for a paraplegic. Two days later, we made the down payment, and we've been here ever since. I doubt we'd ever have that kind of luck again.

All the time I was going from place to place interviewing the disabled, I was sizing up the apartments and houses I was

seeing, trying to determine their accessibility. Most were too small for wheelchair occupants, and some of the ramps were far too steep. Only three or four were totally accessible.

One night, I went to visit Ida, a small, plump woman in her late fifties, who described herself as "an old bugger". Ida lives in a senior citizens' complex, and without the help of a neighbour, she couldn't manage, although her place is designated a "wheelchair apartment".

"It's supposed to be," she grumbled, "but it isn't. The only difference is it has a shower, instead of a bath. Trouble is, once I get in there, I can't shut the door. The bathroom isn't big enough to move around in."

Shaking her head, Ida showed me around the rest of the apartment. "Everything's up so high; I can't turn the switches on or off." I had to admit she was right; I could barely reach them, and I don't have her polio-atrophied arms. "I have a blower on my stove," she continued, "and I can't reach that either." She demonstrated, her fingers falling short of the button by at least two inches.

Ida suddenly laughed, eyes sparkling with devilry, as she remembered the day the complex's architects came in to ask what was wrong with the apartment. "I showed them the mirror in the bathroom, and I said, 'If I'm really lucky, and I stretch my neck really, really far, I can just see my eyebrows. I can't reach the medicine cabinet, and I can't turn the heat up or down. I have a stick to extend my reach, and by poking at switches I can manage a bit with that, but not in the bathroom."

She gave her head a determined toss. "I told them, 'There's all kinds of bugs.'" I suspected Ida had enjoyed that encounter, still, I knew her complaints were deadly serious.

"What they need is a paraplegic on their board when they draw up their plans," she continued.

"Damn right," I heartily agreed.

"I hear that in new places they're putting plugs under the sink," she said wistfully. Motioning to me to follow her, Ida

showed me her outlets, which were tucked away in a corner. "I can't get in there, because I'll catch my foot rests, fall on my face, and have to call for help. What good is that?"

I don't understand how those apartments could have been designed for people in wheelchairs without the consultation of someone informed of a paraplegic's needs. It makes absolutely no sense to build such a facility if it's not going to fit the needs of the tenants, or if the tenants are forced to pay for renovations before moving in. If the architects were unwilling to hire someone who was disabled, couldn't they have borrowed an old chair and taken it into the half-finished building to see where things should be installed?

I was fuming over this pitiful lack of planning, when Ida told me about the worst obstacle she had encountered upon moving in: this seniors' home, supposedly designed for elderly tenants, *had no ramp*!

Enjoying my disbelief, Ida elaborated, "There were seven or eight steps here that were too steep for people with heart troubles, for old people, and certainly for me. It took two years to get that ramp. The problem got shifted from department to department, and it all got snarled in red tape.

"Then the builders wanted to put it in beside the steps, where you'd never get up without a motorized chair, and where, if you came down, you'd land at the bottom of the street before you could stop yourself."

Nor was the ramp the only outdoor problem. Ida's building is only a stone's throw from a large shopping centre, and all the residents wanted a path put in across the field between as they wanted to do their own shopping. Again they ran into red tape: "A priest from a local church didn't want it to go through, because he didn't like the idea of bikers using it. I suggested if they'd send a policeman around once in a while, motor bikes wouldn't be a concern. Then the city was too poor, or so we were told, and on and on!"

After much squabbling, many meetings, and angry phone calls, the elderly and disabled people got both ramp and path

(no one has seen any sign of a motor cycle). Finally, Ida can come and go as she chooses. If somebody would only renovate her apartment, she would be able to live independently.

Single women who cannot take care of themselves, who don't have friends and relatives to help, frequently find themselves in places like Birchwood. Others do well with regular visits from community services. With only a few hours' assistance each week, they, too, can live *independently*.

<center>*</center>

For as long as I've known Dr. Johnson, he has claimed that a car was a paraplegic's legs. The women who drive their own, hand-controlled vehicles know the truth of that statement. As Janice frequently says, "It's my freedom." Unfortunately, only four of my respondents have their licences; the rest of us have to find other means of travel.

In 1964, there was no transportation system designed specifically for the disabled. If my father or fiancé couldn't drive me, I had to take a cab. In other words, I had to take my chances. A handful of drivers were capable of managing wheelchairs; if there were steps at my destination, they could easily whip me up or down, without having to ask for help. However, the majority stared at me, at the chair, and asked, "What am I supposed to do?"

And while the situation was uncertain for me, it must have been impossible for those who could not transfer in and out of a car independently. There weren't many drivers who would risk picking a disabled customer up; they were too afraid of lawsuits should they drop or injure anyone.

It wasn't until 1980, after much lobbying by the disabled population, that Access-A-Bus was born in the Halifax-Dartmouth area, providing regular transportation for those with motor impairment. I registered for the bus early — my card said No. 42 — but until I began interviewing, I had never needed to use it. When I called my first respondent, arranging

a time to see her, I also booked the bus to take me. No problem. The bus would be at my door around 6:30 P.M.

The neighbours soon became accustomed to the sight of the little blue-and-white vehicle, which looks like a truncated form of the regular city bus. At the whirr of the loading ramp, all the children came running, watching with open mouths as the driver put me on board. Inside, there is space for four wheelchairs, plus seats for four who can manage on crutches, walkers, or canes. And from that first drive, I understood why friends had been telling me, "The bus is great. It's going to make a real difference."

"Before the bus," Ida agreed, "I didn't get out at all. Now I've been going to bingos, getting over home, visiting. When my children call, I'm hardly ever here."

Right from the start, the bus was a going concern. People who could never have afforded to take a cab could scrape up a dollar, the initial rate for a trip of any length. Applications for registration poured in.

Then, as more and more people discovered the convenience, problems developed. It quickly became obvious the service was too limited. During peak hours, when people were travelling to and from work, three buses were engaged. Between those times, there were two, and at night, only one. On Saturdays, Sundays, and holidays, the bus didn't run.

In the early weeks of my research, it wasn't difficult to book appointments in the evening, around dinner time, but by September, I was calling a week ahead, just to be certain Access-A-Bus could take me. Arranging to interview people that far in advance became quite a headache; if a prospective respondent had to cancel a session, it took ages to reschedule. Company rules also interfered with some interviews I would have liked to have done; if a dwelling had more than one step, the drivers weren't allowed to take a chair in. They were worried about lawsuits.

In 1982, the service expanded somewhat, and for the first time, we could travel on weekends and holidays (providing

we weren't staying out too long; the hours ended at 7:30 P.M.).
The complaints of the disabled community — that we should
have the same hours as those travelling by the "regular" bus,
and that equal transportation be made a human right —
appeared at first to fall on deaf ears.

But numbers impress bureaucrats, and Access-A-Bus had
650 registered users. At the end of '82, the purchase of three
new buses was announced, and in January, 1983, the service
hours were expanded. Now the vehicles are on the road from
6:30 A.M. — 12:30 A.M. from Monday to Friday, and from
9:30 A.M. — 12:30 A.M. on weekends and holidays. The extra
buses should make it much easier to obtain bookings.

Alas, Access-A-Bus only services the city and its sub-
urbs. For disabled people in most small towns and country
communities, the private car is still the only dependable way
of getting around.

People in these areas can take their chances with intercity
buses, but they might be sorely disappointed. One Nova
Scotia line requires a disabled traveller to have someone to
help her on and off. For a single woman who has no friends
capable of heaving her on, and who knows no one at her
destination to help her off, that rule poses an insurmountable
problem. If she can't find assistance at both ends, she must
forget her trip.

Until recently, trains required a disabled person to have
an escort. Didi was on her way to Montreal when she
heard that unwelcome news. But being Didi, she didn't let it
stop her; she hitchhiked, wheelchair and all. Others might
not have that kind of chutzpah.

VIA Rail has a new, five-year program geared to making
train travel accessible to the disabled. Already, twelve stations
across Canada are equipped with wheelchair lifts. However,
if a person wants to go somewhere that is not so equipped,
the company remains sticky about helping that person on
and off.

The airlines are a little easier to deal with now. Regular wheelchairs are too wide for plane aisles, but CP Air and Air Canada have recently outfitted DC 9s with removable arms on certain aisle seats, allowing disabled passengers to transfer from "one cheek chairs". A one-cheek chair is slightly unnerving, but it works, and airlines staff will help transfer a person onto it, then into her plane seat. Air Canada's new fleet of 767s will have accessible washrooms and on board chairs so we can use them. The future for air travel suddenly looks much brighter.

However, the disabled can't hope for any assistance in getting to a plane washroom. On long flights, this can cause concern. Said Greta, "When I'm going overseas, I have to dehydrate. I don't drink anything for hours before I board. For extra protection, I use Pampers!"

Obviously, it is much easier for the disabled to travel than it used to be, at least over the short hauls. Still, until we find practical, comfortable solutions to the difficulties that hold us back, it'll be years before we can simply get up and go.

Nine to Five

There's an axiom among employers that goes, "We can't hire the disabled because they don't have sufficient education." However, the number of diplomas earned by my respondents proves the fallacy of that argument. Granted, some are a little short on practical skills, but not all jobs require women to type. On the other hand, most of the tasks performed by women are sedentary in nature; they require the women to be sitting down. In fact, the majority of the jobs women do would seem tailor-made for the disabled.

Even accepting the shortage of vocational skills, why then are only 25 per cent (eleven out of forty-five) of the women I interviewed working? Well, four are retired (two of them on doctors' orders), and four are possibly too disabled, but what about the others? As I asked questions relating to employment, the problems the women mentioned had little bearing on age and muscle abilities. On the whole, what I heard about was the attitudes of employers and fellow employees.

Several discussed the problem of persuading prospective employers to look past their disability, reminding me of an episode in my own life. "I don't want someone in a wheelchair messing up the look of my office," he said. I remember wondering what my chair had to do with my potential as an employee. Besides, at the time I was twenty-two, the most agile and

attractive I've ever been. But I was disabled — in a wheel-chair — and he wasn't interested.

When I interviewed Patty, we talked about tokenism. She said her job situation was fine at present, but that when she was first hired she believed her company, a large insurance firm, took her on so the bosses could proudly say, "We don't discriminate. We hire the disabled."

"The person who got me the job was a management technician," Patty explained, "and there was pressure on him. The executive director was going around saying, 'We've got to get this girl a job.' I guess they had to fill their quota of cripples for that year." Patty has the most incredible bubbling laugh, and at this point in her story, it burst out. Nevertheless, I felt the infectious sound was for the most part, a defence mechanism.

Next, she went on to illustrate what I had already heard from other women about the attitudes of employers and other employees vis-à-vis the disabled worker. "I was originally a summer employee," she said. "But he kept me there, and kept me there, and kept extending the time, just until they could find something to do with the little crippled gal."

Then, fortunately for Patty, one of the assistants to the company administrator appeared to care more about her as a person than as a token. He got her into another department as a replacement, and he told her supervisors that eventually he'd like her to become a permanent employee. However, problems followed her, and her fellow workers wouldn't accept her.

"It was dreadful there," she told me. "They wouldn't let me do anything! They practically wrapped me in cotton wool and put me in the corner. Their attitude was, 'Let's put Patty in that office and don't let anyone near her.' They wouldn't let me go to other departments, and they wouldn't let me deal with the clients."

Others had mentioned employers who clearly wanted to keep the disabled worker hidden from the paying public. I wanted to know what Patty was allowed to do.

"They let me take background information on the private clients," she said. "Only I didn't have to leave the room for that. I just sat there and called the people in."

"How long did this go on," I asked.

"About a month," Patty shrugged, "then I got tired of it. That's when I realized what they were doing. They were *testing* me! Was I going to fold under from the way they were treating me? So one day I decided, I really can do everything they're doing; why aren't I doing it?"

"And...?" I grinned, expecting that incredible laugh.

"It was a really bad day," she chuckled. "The work was piled up, and there was no one to do it. So I grabbed all the files, thinking I'm going to take care of these! I could tell what the others were thinking. They were wondering, the computer....Can she handle that?"

Did their reactions make her angry?

"Yes," she said firmly. "They didn't just let it go, thinking, Patty's just like us; she can do the work. Instead they made a really big deal of it."

"They treated you like a kid?" I wagered.

"Right. I was talking to a client, and one of the guys came in. He said, 'Patty, I just heard you went to the other departments all by yourself! Isn't that wonderful!' This was right in front of a client."

"I would have killed him," I snapped.

"I cried," she admitted. "I got rid of the client, and I just cried. I was so *upset* that he would *do* that to me, especially in front of that woman."

"I've never understood why people feel they have to act that way," I said. "I think I might have been tempted to quit."

"I felt I wouldn't survive much longer," she agreed. "And *then* I spoke to the woman in charge of my section. She told me the other girls had talked to her about me. They'd told

her they didn't feel I could function as they could, and when was I going to leave? They said I couldn't reach the filing cabinets as they could, that I couldn't go to the other departments as fast, that I couldn't cope with the clients as fast."

"What did they want you to be?" I asked. "Speedy Gonzales?"

Patty had encountered another problem familiar to disabled women workers; in order to gain acceptance she had to force herself to become twice as good as any of her co-workers.

"I was glad she told me all that. Afterwards I became Super Office Clerk. I became *better* than the others. I could handle thirty clients a day, and since we only did fifty, that left only twenty...for *four* of them! It drove me a little bananas for a while, but finally a permanent job became open in the department. The woman they'd complained to gave it to me without telling them. I'd proved myself to her; she knew I could do the work."

"Did the other women accept you any more graciously then?" I asked hopefully.

"Gradually," Patty smiled. "Yeah, they started accepting me and they didn't take advantage of me. They knew I was a good clerk."

Although Patty spoke lightly of that time in her life, I felt the tension underlining her words. It had been a hard struggle for her. The disabled have to battle for acceptance in every area of life. That fight is rarely easy, and never pleasant. On the job, we frequently respond to rejection as Patty did, by forcing ourselves to be twice as good as everyone else.

Doris, a retired teacher, disabled by polio since she was thirteen, explained why she felt compelled to become Superteacher: "I always felt I had to be superior in my work. I had to be the best in order to get as much credit as the person who did far less, but was physically able. I always felt I had to work harder than the other teachers, and when I got 90 per cent of my students through the provincial examinations, it caused jealousy among the staff.

"I always felt I had to *prove* myself because of the disability," she continued, unconsciously echoing Patty, "and that's *hard*. A disabled person takes a lot on the job that isn't fair; you're not treated in the same light as a nondisabled person. I had to be superior in order to be considered average."

Doris thought for a moment, then added, "But unless you're able to get experience, how can you prove you're just as good?" This is another common barrier. It's often difficult for a disabled woman to convince a prospective employer to give her the chance to try, to see what she can do before passing judgement.

Speaking of employer attitudes, Didi, who's very small and quite deformed, brought up a common theme: excuses. When she registered at a job placement agency, she received a call from a religious organization. "I was talking to the lady," she recounted, "and I made the mistake of saying I was glad the interview was in a building I could get into. She said, 'Am I missing something?' I thought, I dunno; are you? I said, "I'm the lady in the wheelchair who was in a couple of weeks ago."

"And she came up with an excuse?" I guessed.

"Sort of," Didi laughed. "She said, 'Oh! I think there might be a problem with that job.' She called me back later to say there was a shelf in the stock-room that she didn't think I could reach."

Didi shrugged helplessly. "I thought, that's never stopped me before. But...what could I do?"

Whenever we hear alibis that flimsy, we always know the real reason we're being turned down. We're not wanted because we're physically disabled (our other capabilities are ignored). Unless we want to complain to the Human Rights Commission, there's nothing we can do.

I'm sure all disabled job applicants have heard, "You couldn't get into our building." Inaccessibility is sometimes a valid reason for a turn-down; how can a woman work in an office if she can't get into the building?

I was once hired for a weekend job in an inaccessible office; the door was only twenty-two inches wide, far too narrow to admit my chair. The fellow who said, "Welcome aboard," could easily have rejected me but he was a thoroughly decent guy. He not only accepted me, he arranged for able-bodied workers to carry me in, take my chair after me, and lift me back into it. I was quite impressed!

Nevertheless, feeble "too high" excuses can become awfully wearing. Kelly ran into this problem at the last place she would have expected it, at one of the support agencies for the disabled.

"I was there for work experience," she told me. "When I finished, their secretary was leaving to get married. I thought I'd put in an application, and that it wouldn't be any problem. Then they said they wouldn't hire anybody in a chair who couldn't reach the file cabinets."

Kelly finally found work with a supply company, and when I talked to her she was content with her position. "My boss has arranged the office according to my needs — horizontal cabinets, and so on. He built everything to fit me." That's an understanding boss.

*

Most people who reject disabled individuals for employment don't mean to be cruel, however, there are the exceptions, able-bodied people with deep prejudices who deliberately make life hard for the disabled person trying to find work.

Noreen's short arms are the result of thalidomide but, as a rule, they don't hold her back; she even drives a car. She's a busy, intelligent, artistically gifted woman of twenty-four, who has no qualms about speaking in public on behalf of the disabled. "Trying to open up new avenues," is the way she puts it.

I knew she was a student, so when I came to my employment questions, I asked her if she'd ever tried to find a summer job.

"Yes, for the last three years," she replied. "The first year I was very unsuccessful. I think I could have tried harder, but circumstances just didn't go my way."

I urged her to elaborate.

"I went to apply for a job in a store," she said. "They told me there was no such job. That afternoon someone who knew I had applied told me a friend of hers got it. The next day I went to Manpower. They said they really didn't have anything for me, but they could send me chopping trees in Newfoundland."

I'd heard some extraordinary and upsetting things in the months I'd been gathering information; stories of cruelty were not new to me. Still, that kind of sadism shocked me.

"Obviously the girl was getting some kind of joy out of it. She had the jobs and I didn't; she thought she had me over the barrel. I became very upset, and I have to admit, I just gave up."

The next year Noreen decided to steer clear of Manpower. She sent résumés to all the art galleries in the area, got some replies, made a few phone calls, and found a job. "That sounds better," I commented.

"Yes. But this year I had problems again. Because of the location I was in I had to go through Manpower. Again, they pretty well told me I was unemployable."

Fortunately, a friend's summer grant took much of the sting out of that rejection. When an opening came up, she offered it to Noreen. "I took it, and I've enjoyed it," she said.

I couldn't bring myself to ask if she thought she'd ever get used to the cruel excuses and alibis, but I suspect I know the answer. No matter how one steels oneself against them, they really do make it difficult to keep trying. Patty eventually managed to gain acceptance in her company, saying that now, "The girls are great. They don't even see the chair."

However, four years after winning her battle for equality among her peers, she ran into more trouble with management.

"A new superior took an immediate dislike to me, but he couldn't get rid of a permanent employee," she told me. "Not unless I did something really wrong, that is, and I never did. I was an office clerk for four years, then another department had a job come up that I felt I could do."

The new job meant no more shift work and no more weekends. Patty was still very young, and there were other things she wanted to do. She applied.

"He refused even to interview me."

Did she complain?

"Yes, but there was nothing I could do about it. Then I went outside my department, and applied for a secretarial position. Unfortunately the woman who took the application hadn't liked me from the beginning; she never thought I would be a permanent employee."

"She didn't think you'd have the guts to stick it out," I guessed.

"Right. She didn't send my application on, and I didn't find out until the position had gone to someone else. Then I met up with the man who'd been looking for a secretary and he said, 'You should have applied, Patty.' I said, 'I did.'"

The man had never received the application, so that job eluded her. Fascinated, I asked what happened next.

"I spoke to my boss. I told him I intended applying for the job of *his* secretary, asking if he'd consider me. He said yes. This was in August, and every day people would come to be interviewed, and I had to take them to his office. In October, *I* still hadn't had an interview, and I was getting a little worried. Then one day, in walked a girl, and she introduced *herself* as his new secretary!"

"Let me get this straight," I said. "He knew you wanted the job; he said he'd consider you; and he didn't even interview you?"

"That's it," she answered nodding. "I went in and I said, 'I've been in this department five years. Couldn't you at least interview me?'"

"Then what?"

"He told me a lie. He said he and the department head had decided I wasn't worthy of an interview because I hadn't kept up my shorthand. I was just broken hearted; it wasn't true."

"So you went to the department head...?"

"Yeah. I said, 'I have to know. Did you two decide not to interview me?' And she said, 'No! I *begged* him to. I begged him three times.' She felt she shouldn't be involved because she and I were friends, but she'd tried to convince him and she couldn't."

In anticipation, I asked Patty who she'd seen next.

"The assistant administrator of the company," she giggled. "I said, 'I am perfectly capable of handling that job, and I think I certainly deserve the courtesy of an interview.' Well, they called the rat down, and they raked him over the coals. He was suspended!" she hooted. "I was *so* happy. And two days later he was fired!"

"What happened to the secretary he hired?"

"She was in a dither. She'd been there only two days; she didn't know what was going on or what she was doing. Within three months she was fired."

Another opportunity for Patty to apply. "Did you?" I asked, knowing I couldn't have held up under such treatment.

"I was terrified," Patty confessed. "I thought, I'm not going to apply again. I must be crazy to want to put myself through that a fourth time." However, she did apply one more time.

"I was really happy when they gave it to me," she said.

"Finally!" I exclaimed.

"Yeah. Persistence paid off."

There are other Pattys in the disabled community — women who will struggle for years to gain recognition and understanding — but many are not so hardy. When it all becomes too tiring and painful, they resign.

When Didi failed to win the job at the religious organization, she tried a publishing firm. To her vast relief, they accepted her. Nevertheless, she told me she'd come close to quitting it several times, particularly when she felt she was being treated unfairly. She's never had to prove she's twice as good as an able-bodied employee, simply because she's been more or less ignored.

"I'm not challenged the way I like to be," she admitted. "I'd like for them to sit down with me; for us to throw some ideas around. They created my position and then they left me alone with it. I've had very little in the way of guidance."

I wasn't surprised when she added, "Sometimes I feel like their token cripple."

*

Although my interview questions on employment covered several areas, I was most interested in the women's response to the query, "Do you feel you are adequately paid?" A few said yes. Others shrugged, indicating they weren't making a fortune, but could manage. Didi said no.

"I think the position assessment isn't high enough," she went on. "They have me listed as a Clerk I, which is rock bottom. There's a lot more to my job than typing, filing, and answering phones. In addition to all that, I deal with permits and copyrights, I answer my own correspondence, I deal with the clients. A great part of the job is public relations."

"You feel there's prejudice involved?" I asked.

"Oh, yes," she replied. "Definitely, there is. I know that if I weren't so 'needy' and so 'limited' no one else would do it."

"No one else would do so much for so little pay?" I asked. Didi nodded. "It's as simple as that."

However, her salary is above minimum wage, and while she's probably correct in thinking her employers are taking advantage of her, she's paid much more than some.

Sonja is a thirty-five-old black woman whose only noticeable disability is a slight speech impediment. No one would ever guess Sonja has multiple sclerosis. Still, MS once put her in a coma for two years, and when she regained consciousness, her memory was sorely affected. Her conversation is perfectly normal and intelligent, but she has difficulty remembering from one hour to the next.

"I do cleaning," she told me proudly, "and I really love it, especially when I can get a place to stay clean. But I make only $15 a week."

Instantly, I knew where Sonja worked: "a sheltered workshop" for the disabled. She took me back to the source of my interest in wages for I have worked in one of those places myself, and I know what hell they are.

Shortly after Bill and I were married, I wanted to work. I felt I needed to get out of the apartment, and besides, we could use the extra money. A counsellor from the Paraplegic Association began looking for a job I'd like, but nothing materialized. My secretarial skills were poor, my degree unfinished, my familiarity with medical terminology fading. (Then there was that fellow who didn't want my wheelchair despoiling his office.) At a loss, the counsellor suggested I try the workshop. "You won't make much," she admitted, "but it'll keep you busy."

The look of the workshop and the atmosphere inside were straight out of Dickens, but for six months I put up with it, even though it made the old rehab seem like heaven. My task was to type addresses onto metal plates, using a museum-piece machine that vibrated madly against my knees. The vibrations didn't help the gale-force pain I was already experiencing; the pulsations went up my spine until I was shaking all over.

Working eight hours a day, five days a week, at this unpleasant job, my magnificent salary was $24.80 per week. But I didn't protest too much; most of my co-workers made far less. In fact, one young woman who was slightly disabled,

mentally, but who slaved harder than the rest of us combined, was getting $6.50 a week.

We were all disabled. Some had physical problems — arthritis, dyslexia, cerebral palsy; and others were recovering mental patients, using the workshop as a half-way house. Some of the men took training courses, learning the printing trade. However, from the quality of their products it appeared they'd already learned printing and were ready to move on. Indeed, many companies around the city ordered their paper goods from the workshop, at full price, while the workers received only small training allowances.

I guessed our disabilities were responsible for our low pay, and I should have investigated sooner, but I was getting out of the house and the extra cash I was earning helped with my soaring drug bills. So I stayed.

After six months we got a new boss, a social worker with numerous efficiency theories. He looked at my college record and decided I was wasted on the addressograph. He moved me to the office.

It didn't take him long to realize I was totally unsuited to filing and bookkeeping, but he was designing a new project: aptitude and intelligence testing for the mentally disabled. He thought I might be a good person to run it. And the new job was a big promotion. In a place where advancement was rare, it also carried a raise. My salary rose from $24.80 to $30 per week.

I liked working with the teens who were sent to us, and I might have stayed indefinitely, but there came a day when we were called from our individual jobs in order to get a government contract filled in time. The task was simple, collating and stapling pamphlets, and I was bored. So I read as I worked, and quickly realized I was looking at the federal labour laws. A moment later I was tearing toward the boss' office, angrier than I could ever remember being.

I thrust the pamphlet at him. "That says an employer doesn't have to pay the disabled minimum wage," I sputtered. "Is it true, or is it just in places like this?"

"It's true," he replied. "If you calm down, I'll explain."

I tried, but my fury was building. "This clause is here for your benefit," he said. "You see, someone who would not normally hire the disabled might, if he can get them at bargain salaries."

I don't remember most of what I said to him; I doubt it was particularly coherent. Still, I distinctly recall yelling, "I don't call that beneficial; I call it sheer *exploitation!*"

I never went back.

Sonja has worked there nine years, making $15 per week. She said, "There are just two other people who get that. The rest get $10, and if you miss a day, you get docked."

I wasn't overly astonished to learn salaries had decreased in the dozen years since I left, even though the selling price of the goods made in the workshops has soared. The products the workers make have always sold for full market value, and for years, the companies (and governments) ordering such goods have made an enormous profit off the work of disabled people. It seems they're getting even better at exploiting us.

Across the country, thousands of disabled individuals are working in such places. Some are excellent secretaries, others first-rate printers, and others perform menial assembly tasks. They work the same hours as any able-bodied individual. Equal labour should command equal pay.

Nickels and Dimes

"Sixty-five per cent increase in aid to the disabled," announced the Halifax newspaper. In reaction to that claim, the public divided into two camps: either they thought it was about time or they grumbled that the disabled had things too easy. Disabled myself, I was pleased with the increase...but then I didn't know the realities of social assistance. My interview with Marsha set me straight.

"Assistance is three-way funding," she explained. "It's federal, provincial, and municipal. The public hears about that increase, which is provincial, and thinks it's great. What is not understood is that most of the people who receive provincial assistance are also receiving supplemental municipal assistance to help make ends meet. So when they get an increase at the provincial level they automatically lose it at the local level. They'll be no further ahead because when you come right down to it, it remains the same amount of money."

Marsha falls into the middle ground when it comes to assistance. She has more private income than the provincial government will allow. Therefore she is not entitled to provincial assistance or any of its benefits, and these are benefits that the city won't supply. "I've paid my dues," she claimed forcefully. "I paid the insurance premiums when I was working. Canada Pension was established for disability, and it was someone other than I who made that judgement. If I get indexed to the cost of living, if I get an increase in my pension, I believe I should be able to keep that."

I was perplexed as Marsha elaborated: "I receive Canada Pension, but I have to be supplemented out of municipal funds because of the high cost of my housing. My Canada Pension is indexed each year to the cost of living, but I immediately lose that increase through a cut-back by the same amount in my local social assistance."

Helen angrily recounted a similar story during a phone call a couple of days after I had interviewed her. "We just got a $3.00 cost-of-living increase on our provincial cheque. Today we got our city cheque. They've taken it off! They would have done it if the increase had been 50¢! Able-bodied citizens think the disabled have got it made," she said bitterly. "That's a lie. I'll put it this way: we survive. That's about it. I don't live like a queen, the way some people think; I just take my money and live day by day."

Many of the women on social assistance I talked to live well below the poverty line. If they can find work, they can't make more than $100 a month because anything above that amount is taken off their assistance. When I began to ask my interviewees how much their social assistance amounted to, I was unable to find two women who got the same amount. And absolutely nobody understands the system.

I asked Bernice to break down for me the social assistance she receives. She replied that if you are single and living alone the province will pay you $350 for rent, $144 for food, clothing, and miscellaneous, and $24 for lights and heat. That totals out to $518 per month. The city of Halifax allows $265 for rent, $147 for food, clothing, and miscellaneous, and $18 for lights and heat. This adds up to $430 per month. "When the provincial isn't enough to cover expenses, the city kicks in to help," Bernice concluded.

Women like Marsha and Trudy, who receive pensions beyond the limits allowed by provincial, receive only municipal assistance. Trudy, who has two children and whose total monthly allotment (assistance plus pension) amounts to $611, said a woman would have to have four or five children in order to receive full provincial and full municipal.

Provincial social assistance is also responsible for providing funding for devices such as wheelchairs, but even this policy

presents special problems. Bernice described her difficulties in trying to get the proper kind of wheelchair for her multiple disabilities — curvature of the spine, club feet, and cerebral palsy. Social assistance will buy her the hospital-issue $200 chair, but will not provide her with a decent chair that would make her life comfortable. A top-of-the-line wheelchair like mine, for instance, made by Everest & Jennings, costs about $1000. The $200 model Bernice has is no good. They're hard to get in and out of because they don't have pedals that retract, they don't have arms that come off, and they're too unwieldy and break down too quickly.

None of the women I interviewed can understand the social-assistance policy which makes no distinction between those who are disabled and those on general welfare. Helen once tackled a city social worker on that point. "I said, 'Why can't they separate disability from welfare? We have to abide by the same rules, the same restrictions as a person on welfare. We did not ask to go on assistance; my husband worked every day until he became disabled. If he were a well man, he'd be working for our bread and butter. So why can't they distinguish the disabled from welfare recipients?' The social worker replied that he wouldn't touch that question with a ten-foot pole."

Stella has been on assistance for most of her life. I asked if her needs had ever been adequately covered. "No," she replied forcefully. "With my disability, I always say, I picked no cheap disease. My medical costs — not medication, but creams and bandages — run up to $200 a month. When I was home with my parents, they never charged me board; they knew what a tough time I had just paying for my medical supplies. I just bought my high-protein groceries and that was it."

Living with her parents, Stella even had money for clothes once in a while. Then she moved in with her brother and his wife. "I felt obligated to pay them something for looking after me," she said. "Most of my cheque went to them, and Social Services kept the rest." That's when she first felt the loss of human dignity reported by so many women on assistance. "I found it degrading to have to sign my cheque over to my brother because he is legal guardian," she explained. "I can see

it if someone is an alcoholic, or senile, or incompetent with money, but I don't see any reason why *I* had to sign it over. That really got to me."

So did having to buy her clothes by voucher. "When I went to get clothes, I had to get a green slip with the name of the store where it could be redeemed written on it. I can only wear certain styles and materials, and if the first store didn't have what I needed, I'd have to go back and get a green slip for another store. We've chased all over town exchanging green slips. I could be weeks trying to get something to wear."

When Stella wanted to move to a Halifax nursing home so that she could continue her education, her plan opened up another chapter in her long, tiring battle with the social workers in her home town. When she applied to enter Birchwood, the institution received a report on her condition from the municipal social services. "They said in the report I was in bed...and that I needed twenty-four hour a day care. And when the nursing home got this, they believed it because they hadn't met me in person." Social Services told Stella that Birchwood had rejected her for no reason, but she was stubborn and refused to take their word. "I wrote two letters of my own and finally the Birchwood social worker phoned me. She explained what was on the forms. I was just stunned; that lady was surprised I had even gotten to the phone."

Tossing her head, Stella continued angrily. "I have dressings done once a day, I wear clothes, I get out and around. I take part in community activities, I go to school, and eventually I hope to get out working. Social services simply didn't want to pay more to keep me in a nursing home. They were paying my sister-in-law only $200 a month to take care of me. It costs about $80 a month just to keep me on my high-protein diet, so she really wasn't getting much. One worker said he didn't want me to come to Halifax because I'd pick up a germ in my skin and be dead in six months."

Even though Stella had moved into Birchwood in Halifax, her home-town social services remained responsible for her assistance. This is common practice and it can cause enormous problems. The young women in Birchwood told me that their

social assistance is always administered by their home munici- palities because in a nursing home one never establishes residency. Wherever you're from is where your assistance comes from, and according to the women in Birchwood, trying to get money from their small home municipalities is often like "trying to get blood from a stone".

"Now that I'm going to school, I have almost no money left over," continued Stella. After her regular expenses were paid, Stella found herself left with approximately $20 a month. "Out of that, I had to buy school supplies, pay any cabs for trips to the doctor, buy my clothes, and take my spending money. "Getting money out of them is impossible," she sighed. "I need new boots, a winter coat, shirts, school expenses.... They even refused money to send me to the dentist; I've needed a filling for a year. I had to get my doctor to squeeze me in through the Children's Hospital (even though I'm twenty- four), which is covered by Medical Services Insurance, just so Social Services wouldn't have to pay for it. I hope they're proud of that one."

Trudy also mentioned problems in obtaining dental treat- ment. "They don't allow for it," she said. "You can get a tooth pulled, but no dental work. This year, the budget has been cut back so far they won't even buy eyeglasses unless it's an emergency. If you've got a pair of glasses, you've got to make them last. Right now they're trying to stop people from having their teeth out in hospital. Thank God I got mine done last spring; now we're going to have to start paying for it."

A new drug program for the disabled appears to be contri- buting to the general air of discontent and worry. Helen, who is slightly disabled herself and provides all personal care for her quadriplegic husband, told me about it. "It was set up for the disabled on social assistance," she said. "That sounded good, but I thought it would be for the disabled *and* his or her family [if the family is on assistance as well]. It isn't. For my husband, Jack, I can go and get a prescription but it's got to be a drug, and what if he needs Tylenol? They tell me I can buy it over the counter, but that's going to cost money." Helen feels this new system is making her difficulties worse. With Jack's card she can get only prescription drugs for him alone.

"For myself and my daughter, I still have to go to the Children's Hospital. I still have to travel extra."

Psychologists agree that everyone needs recreation and relaxation, but for the disabled on assistance recreation often means television, period. "You don't go out and do the town," said Helen. "You don't get your hair done; you don't go to a bingo game or a show. To go to either, if we both went, would cost over $10. With $10, I can't get a pair of shoes for my daughter, but with another $10, I can get *something* for her. That's why Jack and I don't go anywhere."

I asked Helen if she and Jack ever have a vacation and she became visibly upset. "Only one recently," she admitted. "I don't see why they can't give us one once a year. I'm keeping Jack home, and I'm saving the government the money it'd be paying if he were in a nursing home. I'm expected to stay here and look after him, and if he were to die tonight, where would I be? I can't go out and get a job; I can't take any training....I'd be out on the street. On widow's allowance I wouldn't even be able to stay in this apartment."

When Helen did ask for and get a vacation, it was election year. She'd counted on that, believing the only time the government cares about the disabled is when it comes time to vote. So she spoke to one of the politicians. "His attitude to me was that it was my duty to look after Jack," she fumed. "It's my duty because I'm a woman. I said, 'We'd like a vacation, the two of us. We have to get out of the apartment and away from here for a week or two.' "

Helen admitted a week would have been enough, but when the holiday was finally granted, it didn't measure up to her hopes. "The woman called from Social Services and she offered me $300 for myself but nothing for Jack. I managed to get away for two nights in Cape Breton, and that was as far as the money would take me. I said to that woman to look at all the husbands and wives breaking up after one becomes disabled, and I asked her if she knew why. I told her it was costing them more in the long run." When the woman told Helen they gave out money in case of an emergency, she had a quick reply: "We'll be an emergency pretty soon, because I'm going to land in a mental institution. Then you're going to have to hire someone."

No individual, disabled or not, needs the excess worry. When a woman is constantly wondering how she's going to pay the bills, to feed herself and her family, she can't help but worry. As the system is set up now — with disability equated with welfare — many women feel they've lost their dignity. Helen said, "I feel as if I've been stripped of my human rights! You lose your pride when you lose everything you own, when you have to live like this."

Many women receiving assistance complained about the attitudes of social workers who have become hardened by the system. Trudy said, "It hurts like hell when you have to go to that welfare office and literally grovel, but that's what they make you do....It seems the more down and out you are, the more they fight you. They're supposed to be there to help you, but when you really need them they don't come through."

Bernice concludes, "I'd like to see the social workers and heads of the departments go on social assistance for six months; I'd like them to give up movies, booze, etc. and see how they like it."

Some of the women I talked to mentioned the problem of sexual harassment by social workers. These people, many of whom are male, wield incredible power over assistance recipients. Any can recommend that a woman's assistance be suspended, if they chose, or they can just as easily recommend a raise. Sometimes the worker's attitude can become, "You do what I want, and I'll help you get more money. Don't, and you've had it."

On the other hand, I heard stories from other women about social workers who are appalled at the treatment of the disabled, at how little money those on assistance get. The system doesn't always sour its workers, causing them to lose their sense of humanity.

Trudy hasn't been disabled very long, and she admitted she was greatly surprised by the change in her life-style. "First you have the disability and, with it, the complete change in life-style. You're not even aware it's coming on you, and it happens *so* fast. You suddenly go from being a very active, worthwhile person to where you don't feel very worthwhile. You're trying to convince yourself, I'm still me, but then they take everything they can from you, knock you down in every

way, and you honestly *can't help yourself*. You've got enough problems and worries without them making it worse for you. I automatically thought everyone was being looked after," she continued. "It wasn't till *I* became disabled that I found out nobody does anything to help you. You have to fight for everything you need."

"But you're still supposed to feel grateful?" I surmised.

"Yeah. They want you to feel they're so generous, so kind-hearted, in giving you this vast amount of money. I know the economy is in trouble and they've got to cut back, but this is a really bad time to be disabled!"

I asked Trudy what she felt could be done. "I think the system should be torn completely apart and started from scratch," she replied. "There's so much wrong with it."

Marsha agrees with Trudy one hundred per cent. "I think there has to be a better way," she said. "I think there should be far more control; anyone can take a stroke and be unable to continue employment. Maybe the day will come when we're going to have to have guaranteed income, because there's no other way to keep up with inflation."

"What do *you* feel needs to be done?" I asked.

"I think that there are people in government who need to hear a few more of the stories before they make any more decisions about that," she replied. "I think very few handicapped people — especially handicapped women — are willing to fight for what they should get. There are not many who are willing to say, 'This is how it is, and if you don't believe it, I can prove it.' I feel handicapped women aren't as active as they should be."

"We're back to education again," I commented ruefully.

Marsha nodded. "I really feel that the people who must get everything there is to know about the disabled are the politicians. They are setting the budgets for the various departments that deal with the disabled communities, and in every community those controlling the government's purse-strings require an education."

"And we're going to have to give it to them...?"

"Right. Look," she went on, "too many things are government funded in our world, particularly in the handicapped

world. We've never had a conference without some of the government's money in it, so many people at those conferences find it difficult to bite the hand that's feeding them."

"But...?"

"But we're going to have to learn to....We've got to show people, overwhelmingly, that we want a life for ourselves. Nobody in government really wants to know about our problems," she added, "so we have to force them to know."

"And if we don't?"

"Then we'll always be on the dole."

People Who Need People

"A wheelchair is a real barrier to friendship," announced Dr. Brandt.

Ain't that the truth! When a reporter asked me, "What is the greatest single problem the majority of these women face?" I promptly answered, "Loneliness." When one is seen as "different", it's very hard to make friends. Able-bodied people have to get used to us, and if they're going to be our friends, they have to accept that (apart from the hearing impaired) we can't simply jump up and go whenever the whim takes us. Our lives have to be planned, organized. It seems to me that many able-bodied people can't understand this; or if they do, they resent it.

Not all of us are lonely all the time, but we all know what it is to be lonely. Many of us were deserted by our old friends when we first became disabled, and when I queried various women about current friends, I got some telling answers.

"Do you think the friends you have now can be counted on in a crisis?" I asked Sarah, disabled since the age of ten.

"Not too many," she replied. "Some try. Like I fell out of the bus once, onto the sidewalk. I had four stitches in my head. At the time, the kids didn't know if they should lift me, but they did anyway. They brought me home to Mom and said, "Here. She's yours." But they did come to see me afterwards."

When Alison's friends absconded following her accident, the new attachments she made were all with disabled people.

That was fine in rehab, but now those young men and women are no longer in Halifax. "In a real crisis, I'd turn to my twin sister," she said. "I don't know if I'd even consider calling my friends."

Chris and Cindy, both disabled by muscular dystrophy, find that their friends look to them for strength. "If we were to look to them, they'd be scared," said Cindy. "They rely on us to be one way, and if we're falling apart at the seams, we're disappointing them." I've known people like that and it can be quite exhausting.

The night I talked to Irina, a twelve-year paraplegic in her mid-thirties, she wasn't feeling overly friendly towards the women in her neighbourhood. "I used to be quite close with one," she said. "The back of her property borders on mine, and she used to pop over often. Now I haven't seen hide nor hair of her in two years. When I ask why, she's been "busy". And there's another one. We've never been close, but we were friendly. These days she only calls me when she wants help with her school work."

I asked Irina if she thought her friends sometimes forget she exists. She nodded thoughtfully. "Yeah. They're too wrapped up with their able-bodied friends who can hop over the fence if they want a cup of coffee. In a way, I understand. They've got kids, so their lives are sort of regimented, too. But I only wish they could leave a little room for me."

Some of my own friends are fantastic; others are much like Irina's. When I see them, it's as if we'd never been apart; we get on famously. But then I don't hear from them for months on end, and when I tell them how long it's been, they can't believe it. They're not careless, just thoughtless. If they're going to be pals with me, they're going to have to realize it's not easy for me to get to them; I can't even go into most of their houses unless Bill takes me.

Happily, I now have Elizabeth, the best of all the able-bodied. She'd never been exposed to disability before she met me, but she didn't let the wheelchair bother her. She's great at planning ahead so that we can at least *appear* to be impulsive; she lays the groundwork so that I'm able to get out of the house and do whatever takes my fancy. That's a good

friend. Most of the women I interviewed have at least one Elizabeth in their lives. Still, I worry about those who don't.

Until my research, I had only one close disabled friend; my dynamite rehab roomie, Janice. Since I've met so many terrific women, I've become closer to the disabled community. I don't see my disabled friends as disabled, only as my friends; I hope that's how they see me.

Many of the quotations in this book illustrate the loneliness problem far better than I can; I merely wanted to focus attention on it separately from the other problems. So I think I'll give the last word to Sonja, a thirty-five-year-old black woman with multiple sclerosis.

My question: "Sonja, is there anything you'd like to say to the able-bodied community?"

"What I would like to say is to young people," she replied slowly. "And it's this....Please see us as ourselves, and not just our disabilities. We do have brains, we're able to feel, and touch, and think. So please, just treat us as human beings, first."

Resource Guide

BIBLIOGRAPHY

The following bibliography is by no means complete but is merely an introduction to the literature now available by and about disabled persons. Unfortunately, there is no comprehensive guide produced in Canada but an excellent one has been compiled by the Disabled Women's Educational Equity Project, 2032 San Pablo Avenue, Berkeley CA 94702. The National Film Board of Canada has a catalogue of 16 mm films about the disabled, which it published during the International Year of Disabled Persons. Copies can be ordered from the Film Board at 1 Lombard Street, Toronto, Ontario M5C 1J6. The Canadian Rehabilitation Council for the Disabled at 1 Yonge Street, Suite 2110, Toronto, M5E 1E5, maintains a library, as do some of the Coalition of Provincial Organizations of the Handicapped offices listed under the Self-help and Advocacy Groups section of this resource guide.

Campling, Jo. *Better Lives for Disabled Women*. London, England: Virago Limited, 1979.

Campling, Jo (ed.). *Images of Ourselves — Women with disabilities talking*. Boston: Routledge & Kegan Paul Ltd., 1981.

Canadian Advisory Council on the Status of Women. *Women with Handicaps: Brief to the Special Committee on the Disabled and the Handicapped*. Ottawa: Canadian Advisory Council on the Status of Women, 1980. Write to the Advisory Council, Box 1541, Station B, Ottawa K1P 5R5, for a copy.

Chaussy, Annette. "Deaf Women and the Women's Movement". *Deaf American*, no. 29 (April 1977), pp. 10-11.

City of New York Commission on the Status of Women. *Exploring Attitudes Toward Women With Disabilities: A Curriculum Guide for Employers and Educators*. Write to them at 250 Broadway, Room 1412, New York, New York 10007, for a copy.

Cornelius, Debra; Makas, Elaine; and Chipouras, Sophia (comps.). *Sexuality and Disability: A Selected Annotated Bibliography*. Revised edition. Washington D.C.: Regional Rehabilitation Research Institute on Attitudinal, Legal and Leisure Barriers, George Washington University, 1828 L. St. NW, No. 704, Washington D.C. 20036, 1979. p. 78.

Disabled Women. *Spare Rib: A Women's Liberation Magazine*, no. 80 (March 1979), p. 4.

Duffy Yvonne. All Things Are Possible. Ann Arbor, Michigan: A.J. Garvin and Associates, 1981.

Edmonson, Barbara. "Sociosexual Education for the Handicapped". *Exceptional Education Quarterly*, vol. 1, no. 2 (August 1980), pp. 67-76.

Etzel, Philip, and Nelson, Alice V. *Severely Disabled Women in the Federal Work Force*. Washington D.C.: Office of Personnel Management, 1981.

Fine, Michelle, and Asch, Adrienne. Disabled Women: Sexism Without the Pedestal. *Journal of Sociology and Social Welfare*, vol. VIII, no. 2 (July 1981).

Gallaudet Today. Special issue on "Women and Deafness". (Spring 1974).

Green, Nancy H. "Support Group for Women with Disabilities". *Alert*, vol. 2 (Winter 1979), pp. 7-8.

Health and Welfare Canada. *Disabled Persons in Canada*. Ottawa: Ministry of Supply and Services Canada, 1980.

Journal of Sociology and Social Welfare. Special issue on "Women and Disability: The Double Handicap" (September 1981).

Juni, S. and Roth, M.M. "Sexism and Handicaps in Interpersonal Helping". *Journal of Social Psychology*, no. 115 (December 1981), pp. 175-182.

Kent, Deborah. "In Search of Liberation". *Disabled USA*, vol. 3 (1977), pp. 18-19.

Kriegsman, K. Harris. "Sexuality and Creative Coping Groups for Women with Physical Disabilities". *Sexuality and Disability*, vol. 4, no. 3 (Fall 1981), pp. 169-172.

Lauri, Gini. "A Compendium of Employment Experiences of 25 Disabled Women". *Rehabilitation Gazette*, vol. XX, pp. 3-17.

Linton, Marilyn. "Know the Person, Not Just the Disability: Let's Use the International Year of the Disabled, and Raise Our Children Free of Prejudice". *Homemaker's* (October 1981), p. 6.

Miller, Kathleen S., and Chadderton, Linda M. (eds.). *A Voice of Our Own: Proceedings of the First World Congress of Disabled Peoples' International, November 30 — December 4, 1981, Singapore.* East Lansing Michigan: University Center for International Rehabilitation, Michigan State University, 1982.

Moore, Jean. "Can a Wheelchair-Bound Woman Have a Baby?". *Accent on Living*, vol. 25, no. 4 (Spring 1981).

Neistadt, Maureen, and Baker, Maureen F. "A Program for Sex Counselling the Physically Disabled". *The American Journal of Occupational Therapy*, vol. 32, no. 10. (1978).

Off Our Backs: A Women's News Journal. "Special Issue: Women with Disabilities", vol. XI, no. 5 (May 1981).

O'toole, J. Corbett, and Weeks, CeCe. *What Happens After School? A Study of Disabled Women and Education.* San Francisco: Women's Educational Equity Communications Network, 1978. Available from Far West Laboratory for Educational Research and Development, 1855 Folsom St., San Francisco, CA 94103.

Rehabilitation Literature. *The Special Hardships of Disabled Women*, vol. 43, no. 7-8 (July — August 1982).

Ryerson, Ellen. "Sexual Abuse of Disabled Persons and Prevention Alternatives". *Sexuality and Physical Disability: Personal Perspectives*, David Bullard and Susan Knight, eds. C.V. Mosby Co., 1981.

Sangster, Dorothy. "Let's Make 1981 the Year We Stop Being a Handicap to the Disabled". *Chatelaine*, vol. 54, no. 1 (January 1981), p. 37.

Sauren, Shelley. "Disabled Women Demand Recognition". *The Longest Revolution*, vol. 4, no. 6 (August — September 1980), p. 1.

Saxton, Marsha. *A Peer Counseling Training Program for Disabled Women: A Tool for Social and Individual Change*. Boston: Boston Self Help Center, 1980.

Struck, Miriam. "Disabled Doesn't Mean Unable". *Science for the People*, vol. 13, no. 2 (September — October 1981), p. 24.

Stuart, Charles K. and Stuart, Virginia W. "Sexual Assault: Disabled Perspective". *Sexuality and Disability*, vol. 4, no. 4 (Winter 1981), pp. 246-253.

Task Force on Concerns of Physically Disabled Women. *Toward Intimacy: Family Planning and Sexuality Concerns of Physically Disabled Women*. New York: Human Sciences Press, 1978.

Task Force on Concerns of Physically Disabled Women. *Within Reach: Providing Family Planning Services to Physically Disabled Women*. Everett, Washington: Planned Parenthood of Snohomish County, Inc., 1977.

Vargo, J.W. "The Disabled Wife and Mother: Suggested Goals for Family Counselling". *Canadian Counsellor*, vol. 13 (1979).

Walsh, Terence. "That's Life". *Homemaker's* (October 1980), pp. 114-124.

Weintraub, Laura S. with Flack, Brian L.; Macleod, Catherine; and Schulz, Pat. "Invisible Disabilities: Women with Handicap". *Fireweed: A Feminist Quarterly*, no. 9 (Winter 1981), pp. 89-124.

Wheat, Valerie; Wong, Shirley, and Costick, Rita. "Disabled Women and Equal Opportunity". Women's Educational Equity Communications Network *Resource Roundup* (April 1979), p. 6.

"Women and Disability. Special Problems of Disabled Women".
International Rehabilitation Review (February 1977), pp. 4-6.

Zabolai-Cseke, Eva (consultant). *Women and Disability.* Kit no. 1,
JUNIC/NGO Series on Women and Development, 1981. Available
from Krishna Patel, Editor, "Women at Work", International Labour
Organisation, CH — 1211 Geneva 22.

CANADIAN SELF-HELP AND ADVOCACY GROUPS

Below is a listing of the affiliates of the Coalition of Provincial
Organizations of the Handicapped (*COPOH*). Their offices can
provide information about specialized self-help groups across the
country. For a guide to all organizations dealing with the interests,
concerns, and problems of people with disabilities contact the Informa-
tion Services Department, Canadian Rehabilitation Council for the
Disabled, Suite 2110, 1 Yonge Street, Toronto, M5E 1E5.

COPOH
c/o National Coordinator
926-294 Portage Ave.
Winnipeg, Man.
R3C 0B9
(204) 947-0303

B.C. Coalition of the Disabled
2503 Franklin St.
Vancouver, B.C.
V5K 1X5
(604) 681-8365

Alberta Committee of Consumer Groups of Disabled Persons
4284-93rd St.
Edmonton, Alta.
T6E 5P5
(403) 463-5917

Voice of the Handicapped
1255-11th Ave.
Regina, Sask.
S4P 0G6
(306) 560-3111

Manitoba League of the Physically Handicapped
825 Sherbrook St.
Winnipeg, Man.
R3A 1M5
(204) 775-7530

PUSH-Ontario
Central Neighbourhood House
349 Ontario St.
Toronto, Ont.
M5A 2V8
(416) 923-6725

Carrefour Adaption Québec
472, rue des Commissaires, est
Québec, QC.
G1K 2P4
(418) 522-1251

Miramichi Physically Disabled and Handicapped Association
49 Lobban Ave.
Chatham, N.B.
E1N 2W8
(506) 773-7843

N.S. League for Equal Opportunities
Box 8204
Halifax, N.S.
B3K 5L9
(902) 422-4768

P.E.I. Council of the Disabled
P.O. Box 2128
Charlottetown, P.E.I.
C1A 7N7
(902) 892-9149

Consumer Organization of Disabled People of Newfoundland and
 Labrador (COD)
P.O. Box 422, Station C
St. John's, Nfld.
A1A 5K5
(709) 722-7011